The Story of Photography

AN ILLUSTRATED HISTORY

Illustrations by
Paola Borgonzoni and Giuliana Panzeri

Text by
Giovanni Chiaramonte

Translation from the Italian by
W. S. DiPiero

APERTURE

ACKNOWLEDGMENTS

The publisher wishes to thank the following photographers, agencies, institutions, and galleries, without whose generous assistance this book would not have been possible:

Ansel Adams; Doon Arbus; Archivio Fotografico Alinari; Association Lartigue/SPADEM; Bildarchiv Preussischer Kulturbesitz; Henri Cartier-Bresson; Peter C. Bunnell, Curator of the Minor White Archive; Harry Callahan; William Eggleston; Robert Frank; Gordon Fraser Gallery Ltd.; Michael E. Hoffman; Peter MacGill; Magnum Photos; Joel Meyerowitz; Walter and Naomi Rosenblum; Sander Gallery, Inc.; Stephen Shore; Sotheby Parke Bernet; Joel Snyder; The Paul Strand Foundation; and Garry Winogrand.

CREDITS

Photo credits are listed by chapter. When not otherwise indicated, the credit applies to all photographs in that chapter.
31. Copyright © Association Lartigue/SPADEM. 34. Collection of Walter and Naomi Rosenblum 35. Copyright © 1983 Archivio Fotografico Alinari. 36. *Wall Street, New York*, 1915, copyright © 1971, 1976, The Paul Strand Foundation, as published in *Paul Strand: Sixty Years of Photographs*, Aperture, Millerton, New York, 1976; *The Family, Luzzara, Italy*, 1953, copyright © 1955, 1971, 1976, 1980, The Paul Strand Foundation, as published in *Paul Strand: Sixty Years of Photographs*, Aperture, Millerton, New York, 1976; *Tavern, Luzzara, Italy*, 1953, copyright © 1955, The Paul Strand Foundation, as published in *Paul Strand: Un Paese*, Giulio Einaudi, Turin, 1955. 37. Copyright © 1981, Arizona Board of Regents, Center for Creative Photography. 41. Copyright © 1983 Trustees of the Ansel Adams Publishing Rights Trust. 42. Courtesy Giovanni Chiaramonte. 43. Erich Salomon, Bildarchiv Preussischer Kulturbesitz; Courtesy of Felix Man. 44. Courtesy André Kertész. 45. Courtesy Brassaï. 46. Margaret Bourke-White/*Life* magazine, copyright © 1936 Time, Inc.; W. Eugene Smith, copyright © 1954 W. Eugene Smith 47. Copyright © Henri Cartier-Bresson/Magnum Photos. 48. Copyright © The Estate of August Sander and Sander Gallery, Inc. 49. Cecil Beaton courtesy Sotheby Parke Bernet; Bill Brandt courtesy Gordon Fraser Gallery, Ltd. 50. Copyright © Robert Capa/Magnum Photos. 51. Copyright © Werner Bischof/Magnum Photos. 52. Copyright © David Seymour, copyright © Elliott Erwitt, copyright © George Rodger, copyright © Marc Riboud, all Magnum Photos. 53. Copyright © 1982 The Trustees of Princeton University. 54. Courtesy Harry Callahan. 55. Courtesy Robert Frank. 56. *Identical Twins, Roselle, New Jersey*, copyright © 1967, The Estate of Diane Arbus; *Man in an Indian Headdress, New York*, copyright © 1969, The Estate of Diane Arbus; *Woman with Pearl Necklace and Earrings, New York*, copyright © 1967, The Estate of Diane Arbus. 57. Courtesy Garry Winogrand. 58. Courtesy Ken Domon, Shoji Ueda, Kikuji Kawada, and Ikko Narahara. 59. Courtesy Stephen Shore and Joel Meyerowitz; 60. Courtesy William Eggleston.

The Story of Photography: An Illustrated History was originated and produced by Editoriale Jaca Book, Milan, Italy.
Copyright © 1983 Editoriale Jaca Book, Milan.
English language edition copyright © 1983 Aperture, Inc.
All rights reserved under International and Pan-American Copyright Conventions. English edition published by Aperture, Inc. Distributed in the United States by Viking-Penguin, Inc.; in the United Kingdom and Europe by Phaidon Press, Limited, Oxford; and in Canada by Penguin Books Canada Limited, Markham, Ontario.
ISBN 0-89381-112-X. Library of Congress. No. 83–71376. Manufactured in Italy. Composition by David E. Seham Associates, Inc., Metuchen, New Jersey. Color separation by Carlo Scotti, Milan. Printed by Grafiche Lithos, Carugate, Milan. Bound by LEM, Opera, Milan. Aperture, Inc., a public foundation, publishes a periodical, portfolios, and books to communicate with serious photographers and creative people everywhere. A complete catalogue will be mailed upon request. Address: Aperture, Inc., Millerton, New York 12546.

Contents

BEFORE PHOTOGRAPHY
1 The Discovery of Perspective: Brunelleschi the Painter 2 Capturing the Harmony of Nature: Brunelleschi the Architect 3 The Dawning of the Age of Discovery 4 Extending Man's Vision 5 The Camera Obscura 6 A New Way of Seeing: Jan Vermeer 7 A New Subject for Painters: Everyday Life 8 Drawing with the Camera Obscura: Canaletto

THE DISCOVERY OF PHOTOGRAPHY
9 First Steps: Nicéphore Niepce 10 Picturing Reality: Louis Daguerre 11 The Official Birth of Photography: François Arago 12 The First Photographic Processes

THE EARLIEST PHOTOGRAPHERS
13 The Elusive Image: William Henry Fox Talbot, Sir John Herschel, and Hippolyte Bayard 14 Scottish Masters: David Octavius Hill and Robert Adamson 15 Illustrious Americans: Mathew B. Brady 16 Revealing Character: The Portraits of Félix Nadar 17 New Perspectives: Félix Nadar

FIRST PICTURES FROM DISTANT LANDS
18 The Treasures of Ancient Egypt: Maxime Du Camp 19 The Wet Collodion Process: Multiple Prints 20 The First Photographic Albums: Francis Frith 21 The Crimean War: Roger Fenton 22 Photographer on the Battlefield: Felix Beato

THE AMERICAN ADVENTURE
23 Covering the Civil War: The Brady Photographers 24 Discovering the West: Carleton Watkins, Timothy H. O'Sullivan, and William Henry Jackson 25 East Meets West: Alfred A. Hart and Andrew J. Russell 26 The Epic Tale of the North American Indians: Edward S. Curtis

PHOTOGRAPHY COMES OF AGE
27 Stopping Time: Eadweard Muybridge 28 A Photographer Invents Alice in Wonderland: Lewis Carroll 29 Painting versus Photography: Peter Henry Emerson 30 Pictures for Everyone by Everyone

TWENTIETH-CENTURY VISIONS
31 A Child's Diary: Jacques-Henri Lartigue 32 The First Modern Photographer: Eugène Atget 33 The Champion for Photography as a Fine Art: Alfred Stieglitz 34 Crusaders with Cameras: Jacob Riis and Lewis Hine 35 A Cultural Panorama: The Alinari Family 36 Honoring Humanity: Paul Strand 37 Photography as Transformation: Edward Weston 38 Portrait of the Depression: The Farm Security Administration 39 The FSA and the Common Man: Arthur Rothstein, Dorothea Lange, and Ben Shahn 40 The New Documentary Tradition: Walker Evans 41 The Majesty of Nature: Ansel Adams 42 New Cameras for a Modern Age 43 The Art of Photojournalism: Felix Man and Erich Salomon 44 The Gentle Eye: André Kertész 45 Paris by Night: Brassaï 46 The Photographic Essay: A New Way to Communicate 47 The Decisive Moment: Henri Cartier-Bresson 48 Photographs of an Epoch: August Sander 49 The Two Faces of England: Cecil Beaton and Bill Brandt 50 Defying Death: Robert Capa 51 From Graphics to Great Reporting: Werner Bischof 52 The Photographers' Cooperative: Magnum Photos 53 Making the Invisible Visible: Minor White 54 A Purity of Vision: Harry Callahan

A NEW AWARENESS
55 The Beat Generation: Robert Frank 56 Behind the Mask: Diane Arbus 57 The Social Landscape: Lee Friedlander and Garry Winogrand 58 Japan in Transition 59 In Color: The New Generation in America 60 Snapshots Transformed: William Eggleston

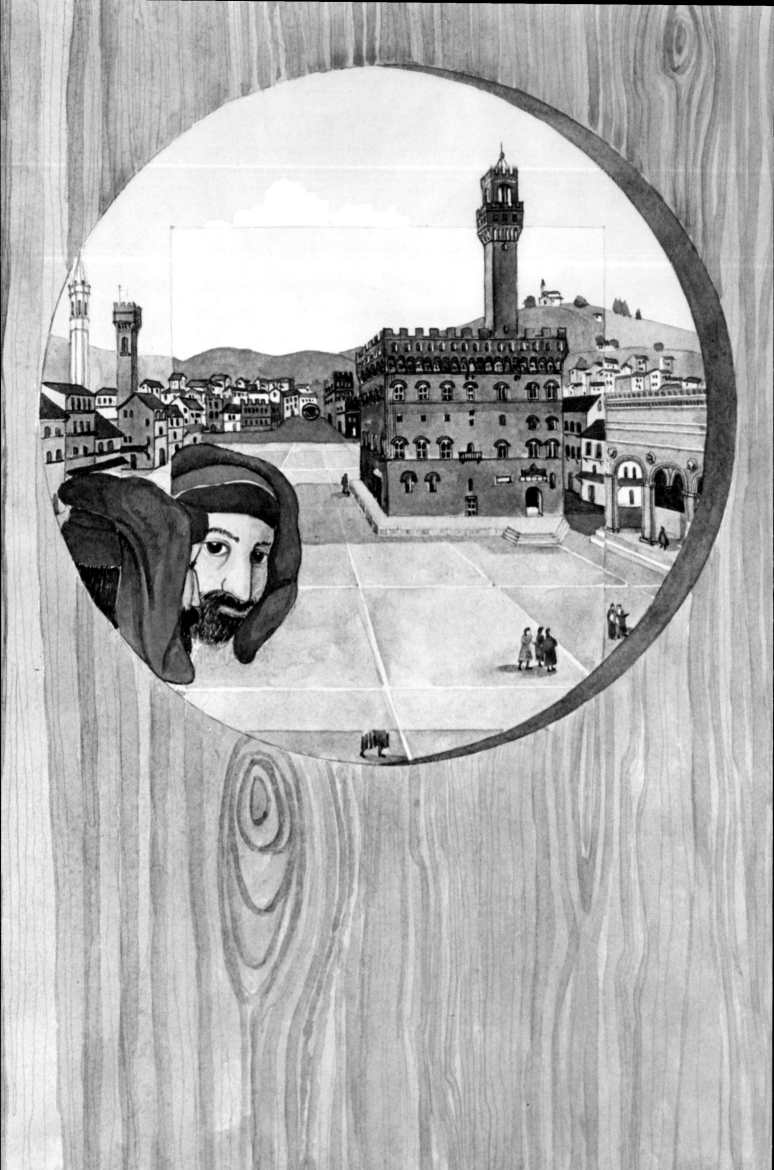

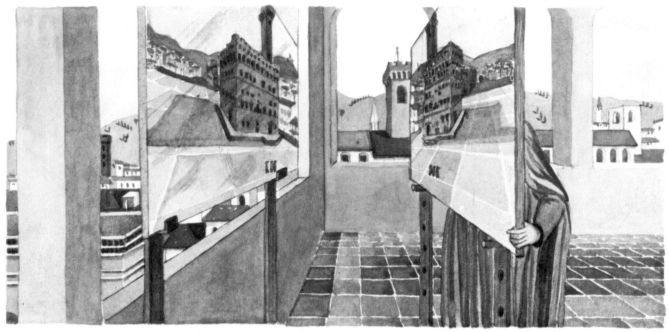

Before Photography

Looking through a hole in the back of the panel, Filippo Brunelleschi sees his painting of the Palazzo Vecchio reflected in a mirror so that it seems to blend into its surroundings.

1
THE DISCOVERY OF PERSPECTIVE
Brunelleschi the Painter

The announcement in 1839 of the discovery of photography was an exciting moment in history. For the first time man could make a picture of the world without using his hands or a pencil or a brush to translate what his eyes could see. Instead, with the help of a device called a camera and metal or paper treated with special chemicals, the photographer could make a picture with light alone. Although the technical procedures for making photographs were invented one hundred fifty years ago, photography had its origins in discoveries made several centuries earlier, during the Age of Humanism.

As the Middle Ages came to a close in the fourteenth century, learned men in Europe began to turn away from studies of religion toward studies of the world around them, experimenting in art, philosophy, and science. The humanists wanted to learn how to make accurate pictures of the world they lived in, and one of the first problems they had to solve was how to show distance, or depth, on a flat surface. The man who discovered the rules for this technique, called perspective, was the Italian architect Filippo Brunelleschi.

Brunelleschi was born about 1377 in Florence, then one of the wealthiest and most important cities in the world and the center of Italian and European culture. As a young man he decided to seek a career as an architect, apprenticing himself to a goldsmith and studying geometry. In order to create his architectural masterpieces—the dome of Santa Maria del Fiore and the Pazzi Chapel, both in Florence—Brunelleschi worked out mathematical ratios that would explain the way the eye sees. His discovery of these principles—actually a rediscovery, since the Greeks had known about perspective as early as the fifth century B.C.—was presented not in a scientific treatise but in two panel paintings, representing the Florentine Baptistery and the Palazzo Vecchio.

In the second panel, Brunelleschi offered an especially dramatic interpretation of his ideas: he drilled a cone-shaped hole into the center of the painting and placed the painting opposite a mirror. Looking through the large end of the hole at the rear of the panel, the viewer saw the Palazzo Vecchio reflected in the mirror. At the top, where the sky had been left blank, a sheet of silver reflected the real sky.

Painters immediately adopted the rules of perspective Brunelleschi proposed. In 1435 Leon Battista Alberti wrote his treatise *On Painting,* and the new method of painting soon spread throughout Western Europe.

Brunelleschi's discovery of perspective was the first link in a long chain that eventually led to the use of the camera as we know it today. Even more important, the humanists' desire for accurate pictures of their world led to experiments that would make that dream a reality.

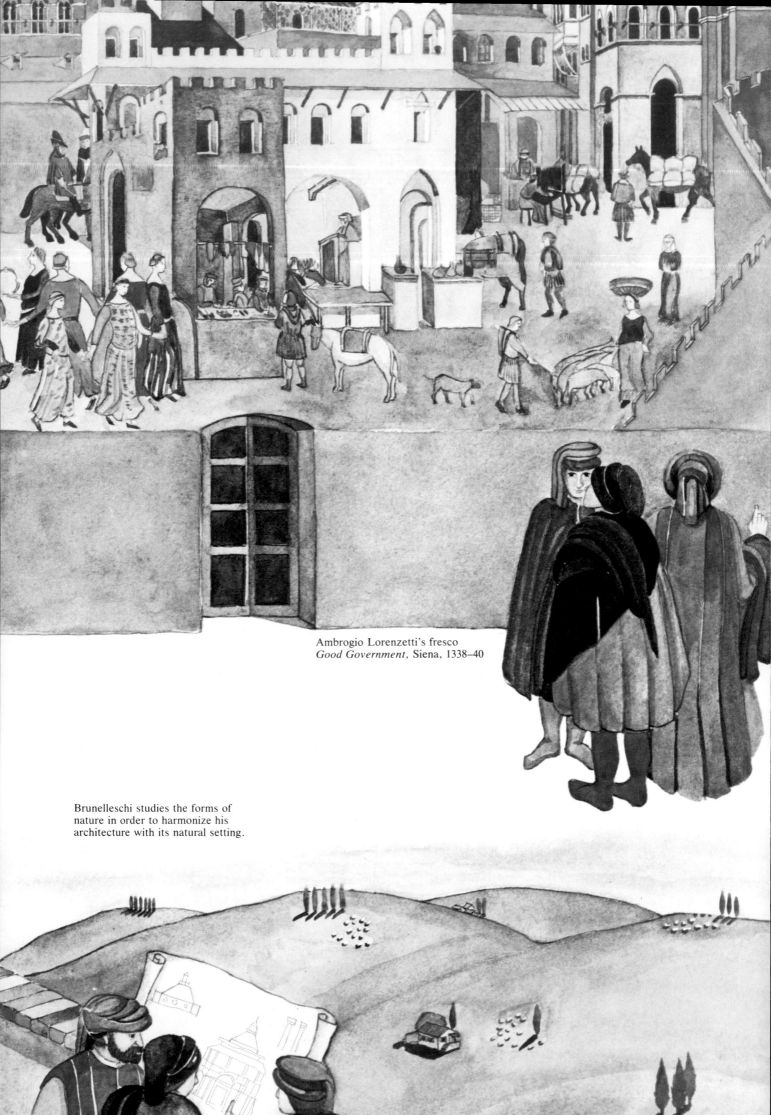

Ambrogio Lorenzetti's fresco
Good Government, Siena, 1338–40

Brunelleschi studies the forms of
nature in order to harmonize his
architecture with its natural setting.

The Pazzi Chapel, built by Brunelleschi in Florence about 1440

2
CAPTURING THE HARMONY OF NATURE
Brunelleschi the Architect

Brunelleschi was an important motivator in the change from medieval to modern ways of thinking. All of his work took place in the context of the new discoveries in physics and mathematics of the period. In spite of dramatic advances in understanding the world, culture was still linked to old traditions. Brunelleschi began to break away from medieval culture and move toward humanist culture.

In the fresco *Good Government* in the Palazzo Pubblico of Siena, the painter Ambrogio Lorenzetti (active in the first half of the fourteenth century) showed for the first time a gentle, ordered landscape where nature is no longer hostile and threatening, as it often is in medieval paintings, but has instead been tamed by man. Man's dominance over his environment, evident in the building of a city like Siena after centuries of decline in urban centers, prefigures man's destiny as master of his world and his universe. At the same time, however, the fresco demonstrates the limits of a culture that had not yet formulated a mathematical method for repro-

ducing the three dimensions of reality in small scale on a flat surface.

With the dome of Santa Maria del Fiore, built over preexistent medieval naves on a site overlooking the city and harmonized with the surrounding hills, Brunelleschi paid his respects to the preceding epoch. In the panel paintings of the Piazza della Signoria, he opened new artistic horizons by solving the problem of three-dimensional representation through the use of perspective. Finally, with the Pazzi Chapel, Brunelleschi built the most significant architectural work of the humanist age; its classical outlines and dimensions would serve as a model for planning the countryside and city in a new way, with villas, palaces, and urban dwellings, instead of dark fortresses and castles with thick walls.

Humanism's ordered, rational approach to painting and architecture, along with its systematic treatment of perspective, anticipated a way of looking at reality that photography would claim as its own.

3
THE DAWNING OF
THE AGE OF DISCOVERY

As humanism spread throughout Europe, it gave a decisive new impetus to science and technology, which were financed by an enormous increase in wealth through expanded trade.

One of the most exciting advances was made in printing. To make a book in medieval Europe, every letter had to be copied laboriously by hand. This made books so rare and expensive that few people owned them or even learned how to read. In Mainz, Germany, probably between 1440 and 1450, Johann Gensfleisch, known as Johann Gutenberg, perfected a printing method using movable type, thus laying the basis for the production of multiple copies of books in uniform editions. At last, the vast hori-

Johann Gutenberg's printing shop in the late 1400s

zons of culture and education, formerly the province of the elite, began to open for large numbers of people.

The technology making the greatest and boldest progress in those days, however, was that of navigation, prompted by the growing political and economic interests of burgeoning national powers, such as Spain, Portugal, England, and France. At the beginning of the fifteenth century, when most ships sailed only on the landlocked Mediterranean Sea, ships were often small, with a single mast. The long voyages on the Atlantic, Indian, and Pacific oceans required more sophisticated ships, with several masts bearing large, heavier sails. The development of the compass and sextant, indispensable instruments for determining direction and position on the high seas, opened the limitless oceans to navigation by European ships.

Aided by these technological innovations, along with an age-old seagoing tradition, Span-ish, Italian, and Portugese navigators made great geographical discoveries, thus revolutionizing man's ideas about his world.

In 1492, Christopher Columbus landed on the shores of San Salvador, a small island in the Bahamas. The event marked the discovery of a new continent. In 1497, John Cabot made the first explorations into the northern part of the New World, and two years later Amerigo Vespucci sailed south along the coast of the continent that would be named "America" after him. Between 1519 and 1522, the Portugese navigator Ferdinand Magellan's expedition made the first circumnavigation of the globe.

Along with the discovery of America and the increased knowledge about the earth, Europeans also made important observations of the infinite expanses of the cosmos. New instruments and new discoveries in subsequent centuries would bring new forms of knowledge—and pose new questions.

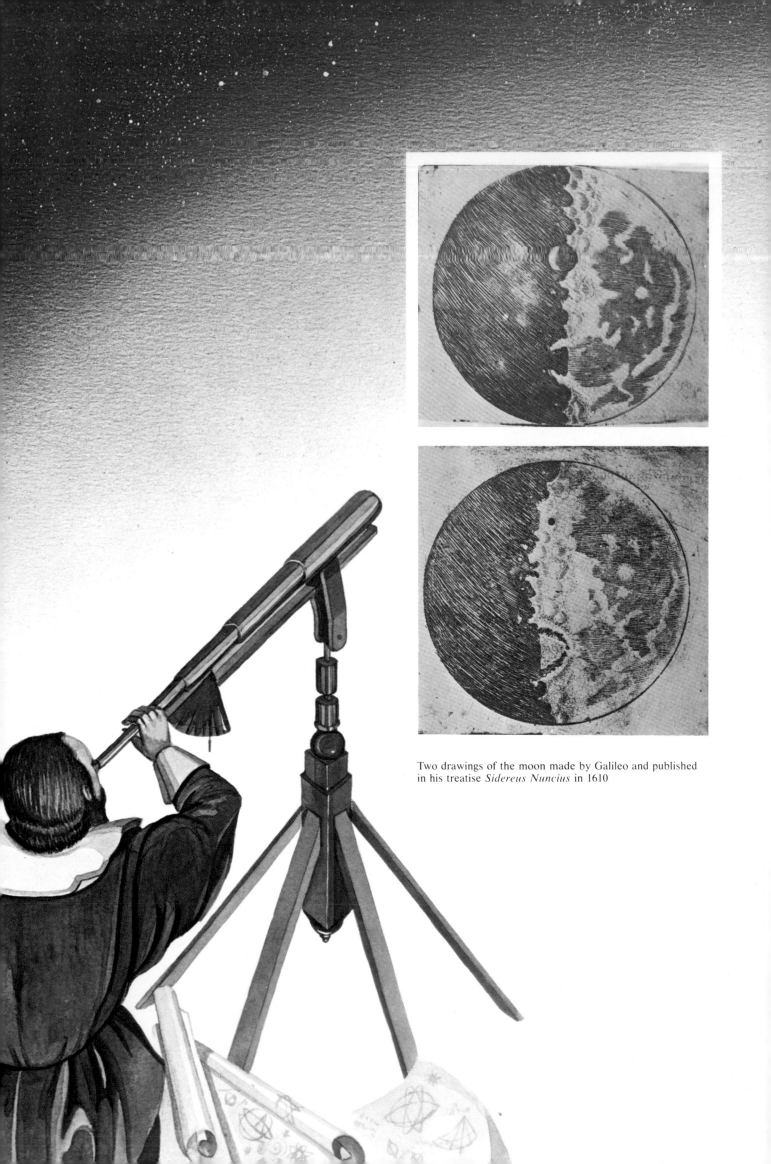

Two drawings of the moon made by Galileo and published in his treatise *Sidereus Nuncius* in 1610

4
EXTENDING MAN'S VISION

The evening sky, studded with stars and illuminated by the moon's pale glow, has always fascinated mankind, but before the seventeenth century astronomers had had to carry out their laborious nighttime observations with the naked eye, never truly penetrating the mystery of the heavens.

In the second half of the sixteenth century the level of scientific knowledge made possible the invention of the first instruments capable of bringing distant celestial bodies closer by enlarging them. At the beginning of the seventeenth century the first telescopes, built in the Netherlands by two craftsmen, Hans Lippershey and Zacharias Janssen, began to circulate throughout Europe. Constructed according to mistaken notions about optics, these primitive telescopes did not produce sharp images on the eyepiece and therefore could not be used for serious scientific observation.

Galileo Galilei, a mathematician and physicist at the University of Padua, learned in very vague terms about the discovery of these instruments. One of the few men of his time capable of applying scientific theories to a practical use, Galileo assembled a model based on the telescopes he had heard about, improving the device by adding higher-quality lenses. According to Galileo, his instrument could enlarge objects almost a thousand times.

Using his new telescope, the scientist then began to explore the sky. What he discovered upset the ideas held by the learned men of his time. Galileo observed sunspots, and mountains and craters on the moon, features that contradicted theories that went as far back as the fourth century B.C., when the Greek philosopher Aristotle proposed that celestial bodies were eternal, perfect, and completely different from the earth.

These observations, and Galileo's discovery in 1610 of the satellites revolving around Jupiter, led him to the conclusion that the earth was not the center of the universe, as people generally believed at the time, but that the other planets must revolve around the sun, a theory formulated nearly a hundred years earlier by the Polish scientist Nicolaus Copernicus. Later confirmed and systematized by the German astronomer Johannes Kepler, the Copernican view of the solar system greatly advanced the sciences and the technology of optical instruments. Even painters would some day benefit from these scientific discoveries because lenses would some day be used to help them make more accurate drawings. Just as the discovery of perspective sometime around 1400 had changed the old method of painting, so, too, the new way of observing subjects through a lens would bring about changes in the painting style inherited from humanism.

THE CAMERA OBSCURA

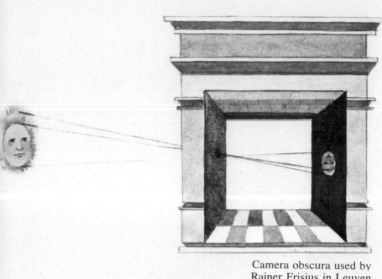

Camera obscura used by Rainer Frisius in Leuven to observe the solar eclipse on January 24, 1544

Camera obscura used out of doors, France, around 1800

Brunelleschi's study of the laws of perspective led to the search for ways to reproduce on a flat surface the three-dimensional reality of objects and figures. Scholars began to reconsider and study the optical phenomenon called the *camera obscura*. It was long known that if a small hole were made in one wall of a dark room (*camera obscura* in Latin), an upside-down image would appear on the opposite wall. In earlier centuries Aristotle had written about this phenomenon, as had Arabic and Oriental scholars. But it was only in the sixteenth century that painters and astronomers tried to exploit it in their work, the painters to help themselves trace outlines that would give perspective, the astronomers to conduct their studies of the sun.

Leonardo da Vinci wrote about the camera obscura, but it was the Dutch astronomer Rainer Frisius who actually used it to make the first drawing. He published a picture of the camera obscura he had used in Leuven to observe the solar eclipse of 1544.

Around 1550, Gerolamo Cardano, a mathematician and philosopher from Milan, suggested attaching a lens to the tiny opening of the camera obscura in order to enhance the brightness and clarity of the image. Near the end of the century Giovanni Battista della Porta described for the first time the use of the camera obscura for making artistic drawings. This innovation became extremely useful for painting landscapes and portraits.

Analyzing Galileo's successful experiments with the telescope, Kepler reached another important stage with the publication, in 1611, of the treatise *Dioptrice,* which described what

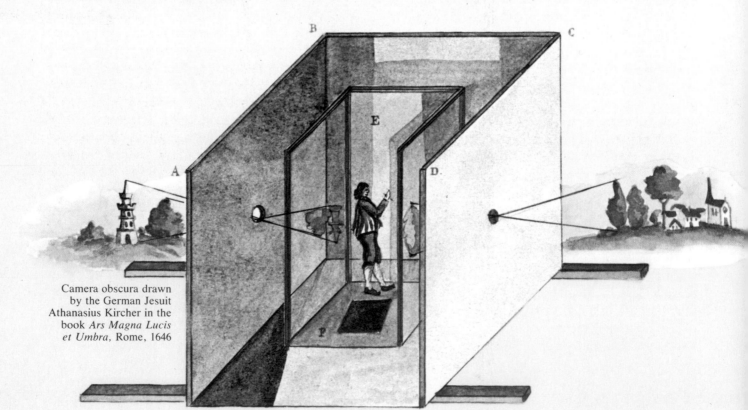

Camera obscura drawn by the German Jesuit Athanasius Kircher in the book *Ars Magna Lucis et Umbra,* Rome, 1646

"Reflex" camera obscura, with a mirror that turns the image right-side up, built by Johann Zahn, Germany, 1685

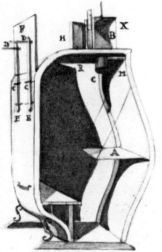

Camera obscura in the form of a sedan chair model, 1711

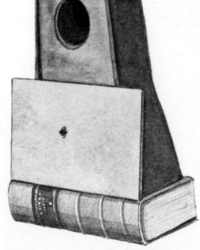

Camera obscura in the form of a book, late 1700s

happens to solar rays when they pass through lenses. A camera obscura made in 1685 by the German Johann Zahn was about twenty-three inches long; in it, the image was turned right-side up by a mirror before it took shape on a translucent glass. Soon it would be possible for an artist to trace on transparent paper the outlines of whatever he had in front of him. In the next century artists, portraitists, miniaturists, travelers, and noblemen all made use of the camera obscura.

The camera obscura may sometimes at first have taken the odd form of a sedan chair or book, but, by the eighteenth century, painters like Canaletto and Bernardo Bellotto used a camera obscura that had already begun to look like a real photographic camera. The various lenses allowed different kinds of framing according to the artist's needs and formed clear, sharply focused images on a ground glass.

But it was not photography, for no one had yet discovered a chemical substance that was not only sensitive to light, but could be desensitized in order to fix a reflected image.

In Germany, in 1727, Johann Heinrich Schulze, experimenting in his laboratory with a solution containing silver salts, noticed that the salts darkened when exposed to the sun. To prove that the salts had reacted to the sun's light, he cut letters into a piece of paper and wrapped the paper around the bottle holding the solution. As he reported, "the rays of the sun passing through the slits in the paper had written words and phrases." By exposing these light-sensitive substances on the glass screen of the camera obscura, and by stabilizing the images that resulted, researchers would eventually be able to "write with light." That would be photography.

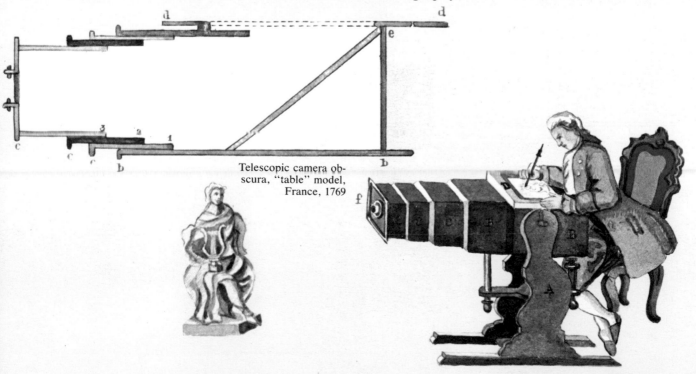

Telescopic camera obscura, "table" model, France, 1769

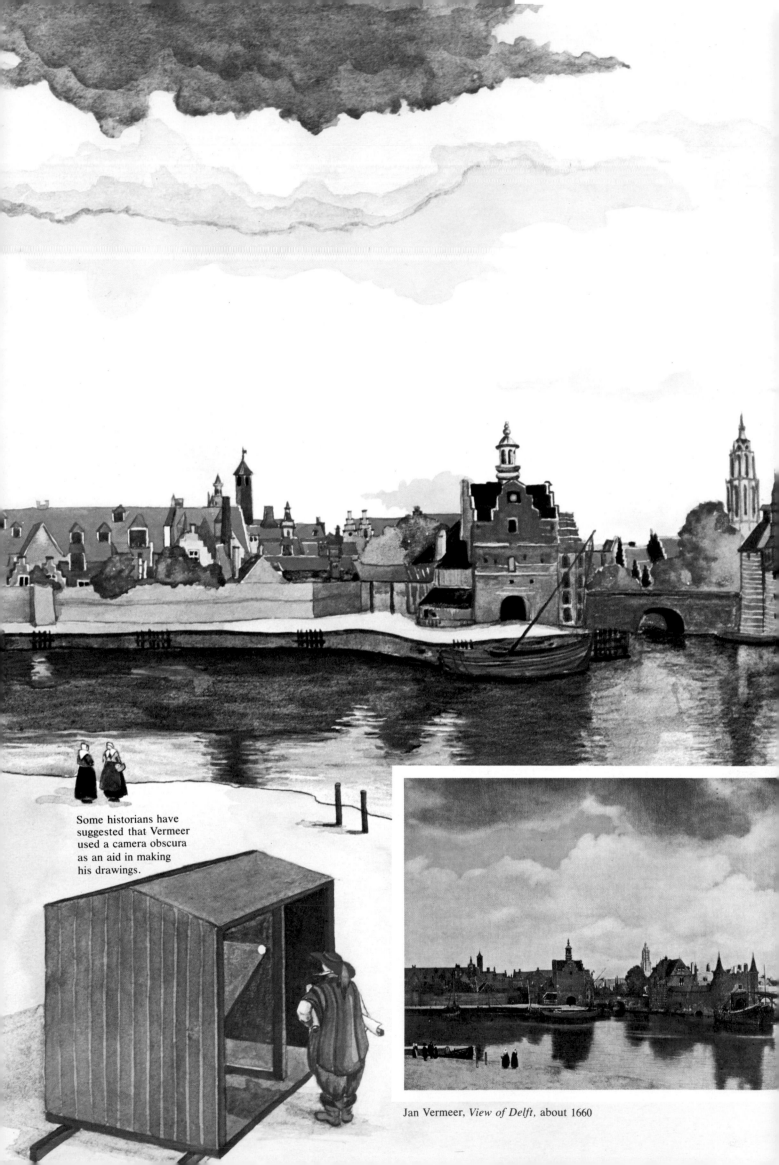

Some historians have suggested that Vermeer used a camera obscura as an aid in making his drawings.

Jan Vermeer, *View of Delft*, about 1660

6
A NEW WAY OF SEEING
Jan Vermeer

Jan Vermeer was born in 1632 in Delft, a small, picturesque town in the Low Countries criss-crossed by the many canals linking the town to the Rhine. Renowned for its ceramics and for a style of painting that attracted artists from all over the country, Delft was also an important center for river and maritime commerce. In Delft, Vermeer could keep in touch with developments in art and thought, and at the same time develop an original vision of painting.

The Delft painter avoided the powerful religious subjects preferred by Peter Paul Rubens and the vibrant portrayals of city officials favored by Rembrandt van Rijn. Instead, he painted the interiors and exteriors of quiet provincial houses whose inhabitants, through hard daily toil, were claiming new territory by building dikes along the North Sea and by acquiring new colonies in America and Asia.

One of his best-known works, *View of Delft,* is a portrait of his native town as seen from the surrounding water. The small strip of buildings appears twice, the second time reflected in the canal. The sky, covered by a thin layer of clouds, fills more than half the canvas. The sun manages to break through some of the clouds, and its light sharply defines the details of the bell tower and roofs rising up on the far side of the bridge.

Although there is no evidence to prove the theory, some people believe that the precise draftsmanship of this painting was made possible by the use of the camera obscura. Just like photographs made with a camera three centuries later, the painting suggests a fleeting, ephemeral experience—an arrested instant in the life of Delft—but *View of Delft* also renders the timelessness of the solid, carefully constructed buildings, the products of modern knowledge and technology. Delft is not an important subject in and of itself, but Vermeer's painting makes it a striking monument to the life and people of a particular town, in a particular country, at a particular time. Because of the painting's success in seizing a moment in everyday life—perhaps with the aid of the camera obscura—many have seen it as the direct predecessor of the art of photography.

Emanuel de Witte,
*Interior with a
Harpsichord,*
about 1670

7
A NEW SUBJECT FOR PAINTERS
Everyday Life

In the fifteenth and sixteenth centuries the countries of Northern Europe became increasingly important centers of commerce and culture. European culture gradually shifted from Italy to the north.

Among these it was the Netherlands that, after achieving its independence from Spain, became most important. Nearly half of all international commerce at that time passed through the Dutch port of Rotterdam and its neighboring port, Antwerp. The Dutch economy, thanks to

agriculture and the continual expansion of colonial possessions, was one of the strongest. The highly developed skills of the guilds allowed for the manufacture of specialized and much sought-after products, including lenses, eyeglasses, and precious stones. Because religious and civil liberties were widely protected and guaranteed in the Netherlands, Dutch thinkers could freely carry on their investigations without fear of persecution. Under this happy combination of circumstances the Netherlands made a substantial contribution to the arts.

With the introduction of perspective, the composition of paintings had changed, but in subject matter painters still used Greco-Roman and Christian themes. But, with the work of Jan Vermeer, the subject matter of painting also began to change. Paintings, earlier seen hanging on the large walls of churches and grand houses, now were commissioned by the middle class, whose houses were smaller and whose lives were more down-to-earth. Apart from his *View of Delft,* the subjects preferred by Vermeer and other painters, and by the new patrons of such artworks, might be *Street in Delft, Woman Reading a Letter, Soldier and a Laughing Girl,* or the painter's own *Studio.*

Thus, Dutch houses had both maps and paintings of everyday life. In a world that had lost the faith in absolutes so important in the late Middle Ages and the belief in the rational order of the universe that was the foundation of humanism, people wanted to possess the entire world and to capture the everyday details of their lives.

Jan Vermeer, *Soldier and a Laughing Girl,* about 1660

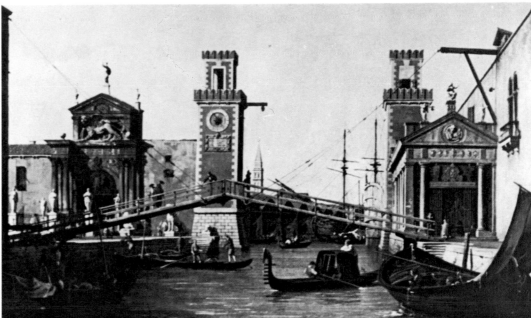

Canaletto, *The Arsenal Bridge*, Venice, 1730

8
DRAWING WITH
THE CAMERA OBSCURA
Canaletto

While Europe's principal trade routes shifted from the Mediterranean to the Atlantic and Indian oceans, the Venetian Republic experienced the last phase of its splendid culture and its thousand years of peace.

Painting in the early eighteenth century was dominated by two figures, born only a year apart, who embodied the contradictory spirits apparent in Venice and throughout Europe. Giovanni Battista Tiepolo, born in 1696, filled his frescos and canvases with allegorical figures, pagan gods, and plump angels flying through fluffy, softly colored skies. His clients were the great noblemen of Venice, the old aristocrats bound to a tradition soon to be disrupted by the rise of the middle class, which was growing steadily richer through trade.

With his sharp, accurate views of Venice and London, Giovanni Antonio Canale, known as Canaletto, born in 1697, expressed the opposite view: reality in its smallest details. To achieve the most precise results he often used the camera obscura, which helped him to study the colors, gradations of light, shadows, and depths of field of the buildings he wanted to paint. With the help of his "artificial eye," he was able to eliminate from his views all extraneous elements, while democratically incorporating every last feature of a scene. His pictures are dense and crowded. They document the richly decorative, showy facades of Venetian palaces and the crowds of city dwellers carrying out the various tasks of their daily lives—holidays, conversations, religious ceremonies, great civic events, business, and work.

Canaletto's use of the camera obscura, though frowned upon by many artists of the time, was praised by the art critic and theorist Filippo Algarotti, who emphasized that the instrument, by framing and reflecting only a limited part of the painter's surroundings, focused his attention on the play of light and color in a particular scene, so that he would not be distracted.

Canaletto's nephew Bernardo Bellotto promoted this way of painting in England, Austria, Germany, and Poland. Bellotto's own paintings of Warsaw were so precise that they were used as plans for rebuilding the town after its destruction in World War II.

Painting thus became documentation, testimony, and a mirror to nature; it anticipated the function of photography, which was to be discovered less than a century later in France and England. It would be no accident that the first book to contain photographs, by the English inventor William Henry Fox Talbot, would be called *The Pencil of Nature*.

The Discovery of Photography

9

FIRST STEPS
Nicéphore Niepce

As early as the end of the eighteenth century all of the cultural and technological elements necessary to the discovery of photography were available: Canaletto's paintings expressed the need for a faithful reproduction of reality; the camera obscura, with its sharp and luminous images cast onto a translucent glass, was a highly developed instrument that could realize this need; and it was already known that chemical substances like silver salts darkened when exposed to the sun's rays, proof that chemistry could transform light into images. Long respected as an important tool in painting, the camera obscura now began to produce images destined to have a life of their own.

In France and England, many researchers had tried to obtain images that required no skill in drawing and could be reproduced easily. In 1786 Gilles Louis Chrétien invented a device that could be used to trace a silhouette projected on a screen. By 1802 Thomas Wedgwood had reported some success at producing images by casting a shadow on a chemically treated surface, but the image disappeared when exposed to light. Credit for producing the first true photograph—the image made by exposing light on a chemically treated surface by use of the camera obscura—has been given to Joseph Nicéphore Niepce.

Niepce was born in 1765 at Chalon-sur-Saône, France. After participating in the Italian campaign with Napoleon's army, he retired to his estate in Gras, where he and his brother Claude devoted themselves to a wide range of scientific research. Around 1813, Nicéphore Niepce became interested in lithography, the revolutionary printmaking technique invented about 1796 by Aloys Senefelder of Germany. This simple method exploited the capacity of certain rocks to absorb water.

After the artist had made a drawing with a greasy crayon on a piece of limestone and had treated it with nitric acid, he or his assistant soaked the stone with water. When the surface was coated with oily printer's ink, the ink stuck only to the greasy drawing, not to the wet spots. Finally, the drawing was transferred to the paper. The lithographic stone had a great advantage over metal engraving, because it did not have to be cast. Each stone could yield several hundred inexpensive, high-quality prints.

Niepce, who drew poorly, tried to improve this invention by finding a system for transferring an original picture directly onto the stone, bypassing the intermediate recopying stage. Information about his experiments is limited, but we know that for years he experimented with the darkening properties of silver salts when exposed to light, but never found a way to control the chemical action. In April 1816 he wrote to his brother, "The experiments I have thus far made lead me to believe that my process will succeed as far as the principal effect is concerned, but I must succeed in fixing the colors; this is what occupies me at the moment, and it is the most difficult." Frustrated by his failure, Niepce went on in the next few years to experiment with other light-sensitive materials. He finally achieved some success by applying bitumen of Judea, a substance commonly used in lithography, to lithographic stones and polished pewter plates, a new technique that he called *heliography*. In the course of his research, probably during the summer of 1826, Niepce inserted one of these plates into a camera obscura, and, after more than eight hours, removed it to discover on the plate a fuzzy view of the Gras estate as seen from his window. Thus, Niepce created what some consider to be the first photograph in history. In this vague image the white sections are those treated with bitumen of Judea, which turns light in the sun, and the dark sections the polished pewter plate.

Despite his efforts, Niepce never succeeded in producing a sharp image; the bitumen reacted too slowly to sunlight. In 1829, after three years of correspondence and negotiation, he entered into a partnership with Louis Jacques Mandé Daguerre, a painter, entrepreneur, and inventor with whom he finally managed to obtain satisfactory results. Although his discoveries helped pave the way for future practical applications of photography, they did not make Niepce a wealthy man. He died neglected and impoverished in 1833.

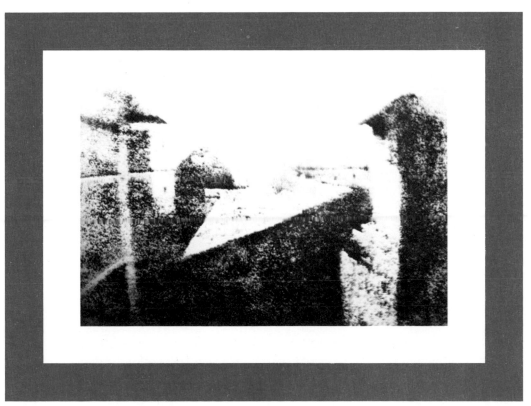

Nicéphore Niepce, *View from his Window at Gras*, 1826

Nicéphore Niepce Louis Jacques Mandé Daguerre

10
PICTURING REALITY
Louis Daguerre

In 1829 when Louis Jacques Mandé Daguerre went into partnership with Niepce, hoping to reach the goal of fixing the fleeting image produced by the camera obscura, he had already made a name for himself as the impresario of the Diorama, one of the most peculiar and popular public attractions of the time.

After first studying architecture in Orléans, Daguerre moved to Paris, where he spent a few years as the painter Pierre Prévost's assistant, then went on to paint scenes for the Paris Opéra. Though certainly not a profoundly original, visionary artist, Daguerre was a virtuoso with a brush; his scenes and landscape backdrops for the Opéra were extremely well executed.

At the age of forty-two, having mastered painting technique and stage lighting, Daguerre, working with Charles Bouton (another of Prévost's pupils), invented a new kind of entertainment, the Diorama. Looking through a window-shaped opening, the viewer watched a screen that had been painted on both sides with transparent colors—light, subtle hues on the front; strong, dramatic hues on the back. When the audience entered the theater, house lights projected on the front side of the canvas made the painted view appear to be in "daylight." As the lights in front dimmed, light projected from behind gave a nighttime effect, revealing details of the scene that had previously been invisible. The Diorama promptly aroused the awe and enthusiasm of spectators in Paris and London and was favorably received by the press.

Daguerre's activities as an illusionist led him to other experiments with images that mirrored reality. By collaborating with Niepce he hoped to arrive more quickly at the conclusion of research he had begun in 1824.

Of the two, only Daguerre was on the right track. His method, invented in 1831, promised success because it relied on the light sensitivity of silver salts rather than the bitumen of Judea used by Niepce. When Niepce died, his son Isidore continued the partnership with Daguerre, who was close to reaching the goal. In 1835 Daguerre found that he could significantly reduce the time that a plate had to be exposed to light, but the image could not be stabilized. Two years later, he had some success with stabilizing the image with a concentrated salt solution.

In 1838, François Arago persuaded the partners, who had failed to sell their invention to private industry, to turn over the rights to their invention to the French government. Arago, director of the Paris Observatory, secretary of the Académie des Sciences, and an influential member of the opposition party in the Chamber of Deputies, would make the legendary announcement of the discovery made by Daguerre based on Niepce's research.

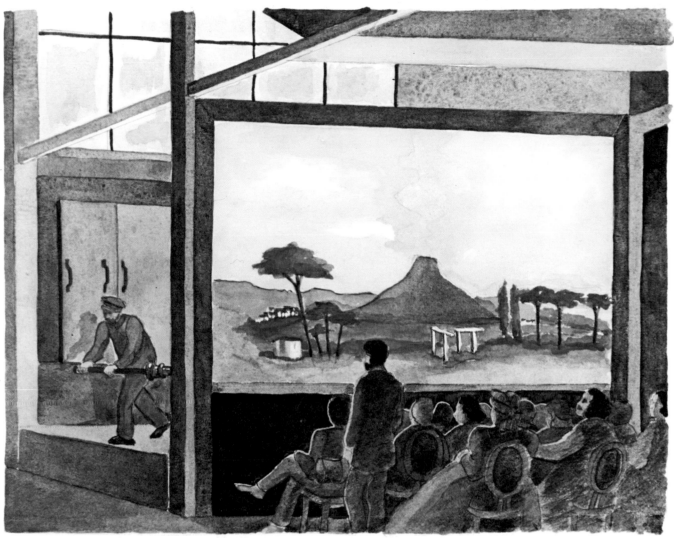

Diorama of Mount Etna, London, 1850

Anonymous,
Family Portrait, about 1840,
made using Daguerre's method

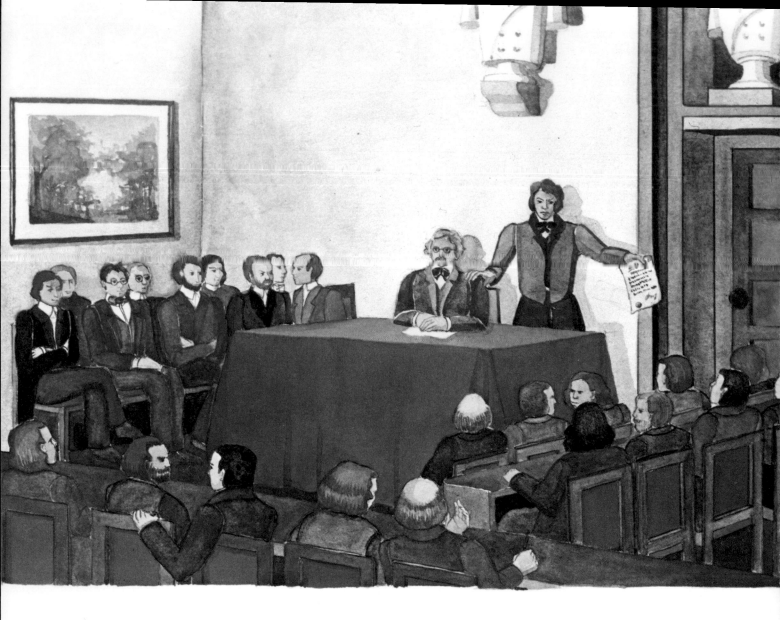

11
THE OFFICIAL BIRTH OF PHOTOGRAPHY
François Arago

Authorized by Daguerre and Isidore Niepce to arrange for a patent from the French government, François Arago sought the support of his colleagues by delivering an impassioned report to the Académie des Sciences on January 7, 1839: "Everybody knows the optical apparatus called the camera obscura invented by della Porta; everyone has noticed with what clarity, truthfulness of form, *color,* and tone, external objects are reproduced on the screen placed at the focus of a large lens which constitutes an essential part of this instrument; and everyone who has admired these images will have felt regret that they could not be rendered permanent.

"From now on there will be no need for regret, for M. Daguerre has devised special plates on which the optical image leaves a perfect imprint—plates on which the image is reproduced down to the most minute details with unbelievable exactitude and *finesse.* In fact, it would be

no exaggeration to say that the inventor has discovered the means of *fixing images,* if only his method preserved colors; but I must hasten to explain, in order not to deceive the public, that in M. Daguerre's copies—as in a pencil drawing, an engraving, or, to make a more correct comparison, in an aquatint-engraving—there are only white, black and gray tones representing light, shade, and half-tones. . . . M. Daguerre has shown three members of the Academy, MM. de Humboldt, Biot, and myself, some results achieved by his process. . . . All these pictures bear examination under a magnifying glass without losing any of their sharpness. . . . The time necessary for taking a view, when one wants to achieve great vigor of tone, varies with the intensity of the light, the hour of the day, and with the season. In summer at midday, eight to ten minutes suffice."

Arago concluded by listing the various fields

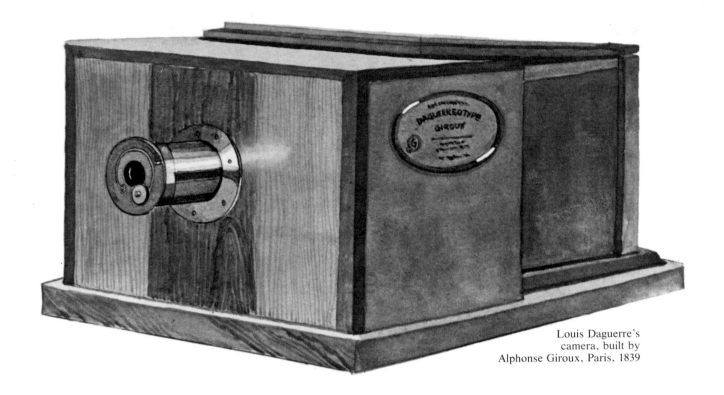

in which the new invention could be used. Though the inventors kept the details secret, the national and foreign press began to report news of the remarkable discovery. Following this announcement, other inventors stepped forward to stake claim to their own contributions. Among them were William Henry Fox Talbot in England and Hippolyte Bayard in Paris.

But this competition, thanks to Arago's diplomatic skill, did not interfere with negotiations for the patent. On June 30 the contract was signed, according to which "Daguerre and Niepce junior agreed to consign to the Ministry of the Interior the process of Niepce senior and the refinements of Daguerre for fixing the images of the camera obscura. . . . As compensation for these rights the Ministry of the Interior shall request from the Parliament for Daguerre . . . an annual pension of 6,000 francs for life. For Niepce junior . . . an annual pension of 4,000 for life." On August 19, 1839, seven months after his first announcement, Arago revealed the secrets behind the discovery, and the process called *daguerreotype* began to spread rapidly throughout the world.

To view a daguerreotype
the plate must be tilted to
eliminate the glare from
its polished surface.

Glass-covered case
for preserving
a daguerreotype

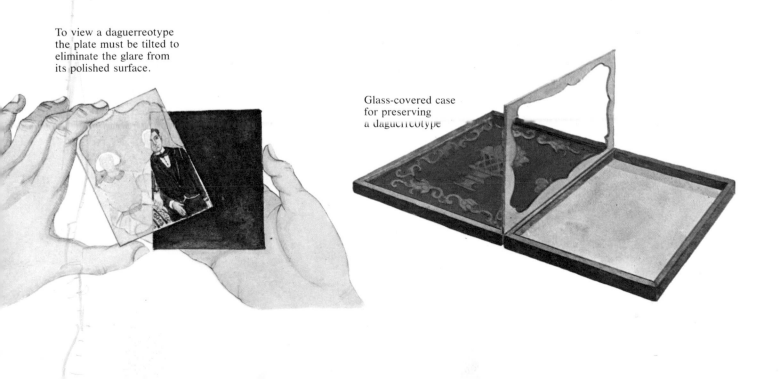

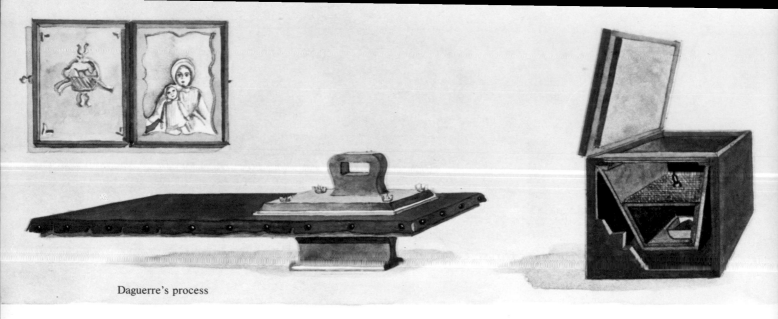

Daguerre's process

12
THE FIRST PHOTOGRAPHIC PROCESSES

"The mirror with a memory" is surely the best nickname for the daguerreotype, the thin polished metal plate on which the French inventor managed to fix the images made by the camera obscura.

Daguerre's procedure involved a series of relatively simple operations:

1. A silver-coated copper plate was polished to mirror brightness.
2. Next, the plate was fumed with iodine, which reacted on contact with the silver forming a transparent coating of silver iodide.
3. Now sensitized, the plate was inserted into a camera obscura. The camera was then pointed at the desired subject for a period of five to sixty minutes, depending on the lighting conditions. (After this "exposure," no image could be seen on the plate; it had to be treated with other chemicals.)
4. Once this operation was completed, the plate

was "developed" with mercury fumes, which made the subject visible in the form of a grayish-white veil.
5. To stabilize and fix the resulting image, the plate was dipped into a concentrated sodium chloride solution or a bath of sodium thiosulphate solution, which removed the iodide not struck by the sun's rays and fixed forever the sections covered by the grayish-white veil.
6. Finally, the plate was rinsed in distilled water, dried, and mounted in a small case under glass.

In the daguerreotype the bright areas of the image were created by the thin, opaque grayish-white veil, the shadows by the parts that had remained clear.

For its brilliance of tone and precision of detail the beauty of the daguerreotype could not be matched, but it also had some serious shortcom-

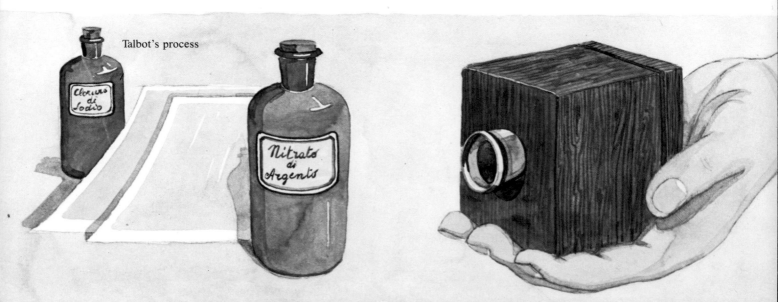

Talbot's process

ings: the plate's surface was very delicate; the plate was so shiny that it had to be tilted to avoid glare; and, most important, it was impossible to make prints from the daguerreotype plate.

In the same years, William Henry Fox Talbot, unaware of the process invented by Niepce and Daguerre, developed a procedure that did not have these drawbacks, although it could not equal the daguerreotype in sharpness of detail.

An English scientist born in 1800, Talbot first became interested in fixing the image made by the camera obscura in 1833, while using the device to make sketches on the shores of Lake Como in Italy. A few years later he succeeded in making a tiny image less than an inch square, but he had not yet published results of his experiments when news reached him of Daguerre's success. As soon as he heard about Arago's speech to the Académie des Sciences in Paris, Talbot immediately rushed to publicize the results of his experiments in a detailed report read to the Royal Society in London on January 31, 1839, and released to the press immediately afterward.

Talbot's method used paper rather than a metal plate, and, unlike Daguerre's one-step process, it required two distinct stages of operation. In the first stage, an impression of the subject was made with the camera obscura, and in the second, the final image was printed in identical copies.

To obtain his first results, Talbot brushed a sheet of paper with a weak sodium chloride solution (common table salt), then saturated the paper with light-sensitive silver chloride. The sensitized paper sheet was then exposed in the camera obscura for roughly one-half hour. In this process the lightest areas of the subject darkened, while the darker areas remained light.

Next, Talbot rinsed the sheet with salt water, which fixed the image but left the bright and dark areas in reverse. To correct the tones the sheet was placed on another sensitized sheet and exposed to light again, producing an image with the same light and dark areas as the subject had in reality.

Since it used paper rather than metal plates and could be used to make more than one copy, Talbot's system was much more practical and economical than that of Niepce and Daguerre, and it ultimately became the source of all subsequent improvements. For the moment, however, the daguerreotype method gave the best results. Because the chemicals used to fix the image made with Talbot's process were unreliable, the images frequently faded, and their mistiness could not compete with the daguerreotype's crisp, clear outlines.

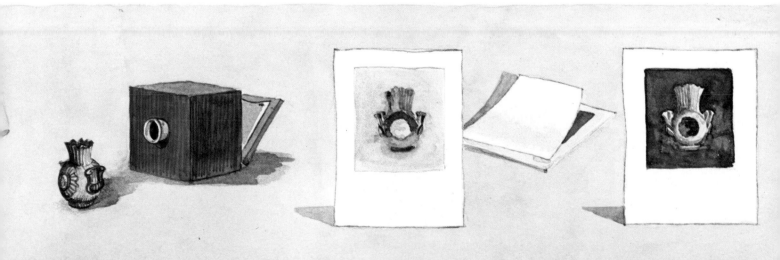

The Earliest Photographers

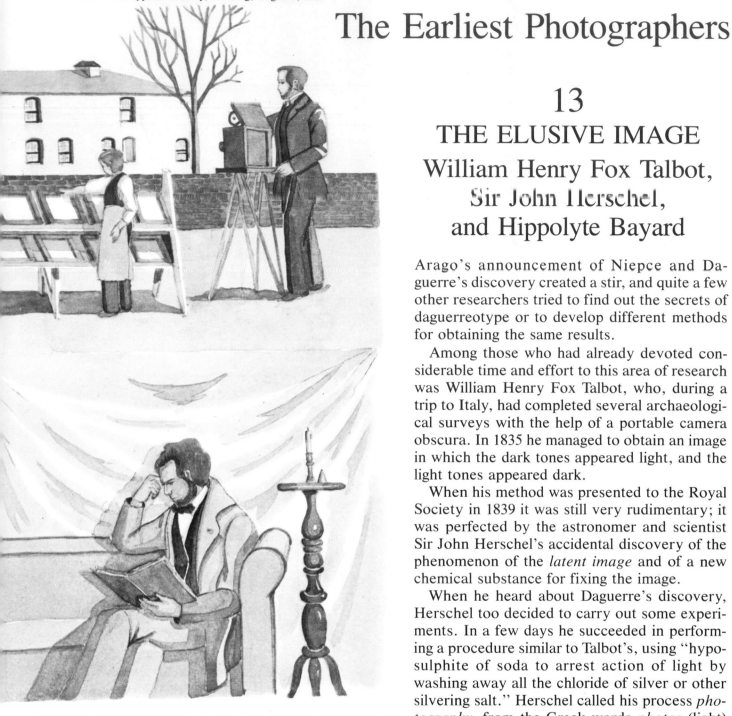

13
THE ELUSIVE IMAGE
William Henry Fox Talbot, Sir John Herschel, and Hippolyte Bayard

Arago's announcement of Niepce and Daguerre's discovery created a stir, and quite a few other researchers tried to find out the secrets of daguerreotype or to develop different methods for obtaining the same results.

Among those who had already devoted considerable time and effort to this area of research was William Henry Fox Talbot, who, during a trip to Italy, had completed several archaeological surveys with the help of a portable camera obscura. In 1835 he managed to obtain an image in which the dark tones appeared light, and the light tones appeared dark.

When his method was presented to the Royal Society in 1839 it was still very rudimentary; it was perfected by the astronomer and scientist Sir John Herschel's accidental discovery of the phenomenon of the *latent image* and of a new chemical substance for fixing the image.

When he heard about Daguerre's discovery, Herschel too decided to carry out some experiments. In a few days he succeeded in performing a procedure similar to Talbot's, using "hyposulphite of soda to arrest action of light by washing away all the chloride of silver or other silvering salt." Herschel called his process *photography,* from the Greek words *photos* (light) and *graphia* (writing). For the paper first exposed in the camera obscura, in which the light and dark tones were the reverse of those in reality, he coined the term *negative;* and for the final print in which the tones had been corrected, *positive.* The negative-positive process is the basis for photography as we know it today.

With the use of hyposulphite of soda as a fixing agent, the positive image resisted fading and could be preserved for a long time. Talbot later succeeded in reducing the required exposure time to just a few seconds, and he patented his system under the name *calotype.*

Talbot and Herschel were not the only inventors to develop a photographic procedure based on a paper negative in the early months of 1839. Shortly after Arago's announcement to the Académie des Sciences Hippolyte Bayard, an

William Henry Fox Talbot, *Still Life, London,* 1840

unassuming French bureaucrat, succeeded in inventing a process that used silver-chloride paper which was allowed to darken in sunlight, then was dipped in potassium iodide and exposed in the camera. The light bleached the dark paper, yielding a positive paper print. In June Bayard organized an exhibit of thirty prints at a charity bazaar, surely the first exhibition in the history of photography. Arago, loyal to Daguerre and fearful that his negotiations with the government on behalf of Niepce and Daguerre would be compromised, obtained for Bayard a contribution of 600 francs for a new camera, convincing him in the meantime that his research was still not very satisfactory.

In fact, Bayard had invented a workable photographic method, but by the time he had made his invention public in 1840, the daguerreotype was in use all over France, and Daguerre had become a national hero. When he realized that Arago had tricked him, Bayard put on a ghoulish performance. He photographed himself pretending to be dead, and he wrote on the photograph the following caption: "The body you see is that of M. Bayard, inventor of the process with which you are now familiar. . . . The government, which gave M. Daguerre too much, said it could do nothing for Bayard at all, and the wretch drowned himself."

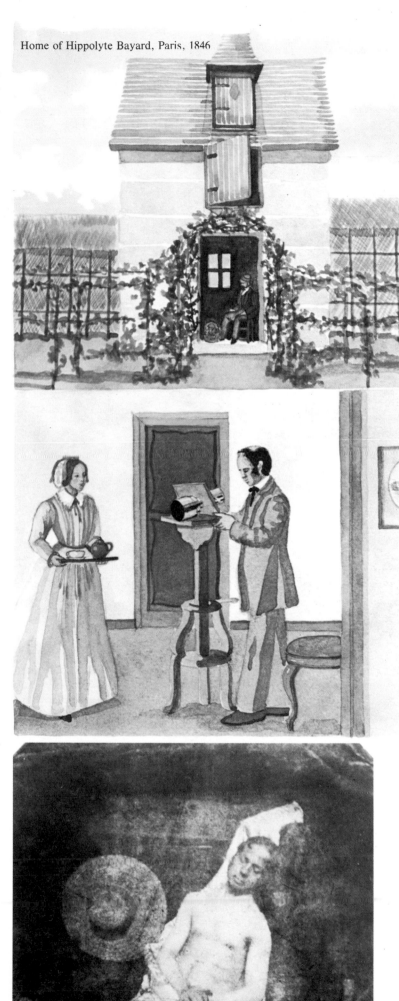

Home of Hippolyte Bayard, Paris, 1846

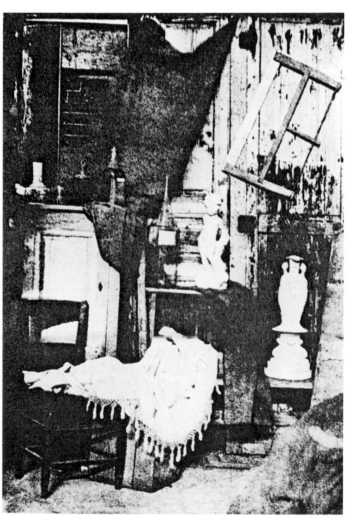

Hippolyte Bayard, *Objects in the Studio,* about 1846–48

Hippolyte Bayard, *The Drowned Man,* 1840

14

SCOTTISH MASTERS
David Octavius Hill and Robert Adamson

Talbot's calotype method and the improved *Talbotype* also gained popularity. In Scotland, John Adamson was one of the first to develop a series of photographs with Talbot's method, and his brother Robert, who was unable to complete his engineering studies because of poor health, decided to devote himself professionally to photography and opened a studio in Edinburgh that quickly became a success. In that same year, 1843, the Church of Scotland declared its independence from the Church of England, and commissioned the painter David Octavius Hill to paint a large canvas depicting this historic event, including the faces of every one of the nearly 500 delegates to the founding convention.

Given the usual means available to a painter, it seemed an impossible task. But, by this time, Hill had met Robert Adamson and had himself taken up photography. Working together, Hill and Adamson made all the photographic portraits Hill would need to execute the painting. After Adamson's death in 1848, Hill gave up

photography because of family pressure and returned, probably unwillingly, to painting, completing his enormous canvas in 1866. Like the rest of his paintings, this picture is not very distinguished. Despite his family's wishes, any fame he had came from the truly inspired photographs he made with Adamson.

From 1843 to 1848 the two men took almost 2,000 photographs that faithfully captured life in Scottish cities of the time. Hill's careful artistic direction and Adamson's disciplined sense of composition combined to produce pictures that reveal the essential character of the people portrayed—Matilda Rigby's charming sweetness, for example, and the stalwart dignity of New Haven fishermen. After a long period of neglect, Hill and Adamson's photographs were rediscovered early in the twentieth century and published in the periodical *Camera Work*. They would become a crucial point of reference for modern portrait photographers.

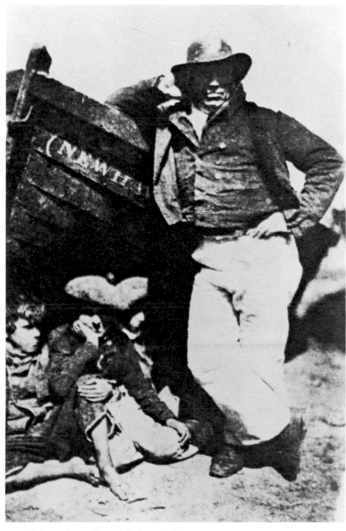

David Octavius Hill and Robert Adamson,
James Linton, New Haven, about 1843

David Octavius Hill and Robert Adamson,
Miss Matilda Rigby, Edinburgh, 1843

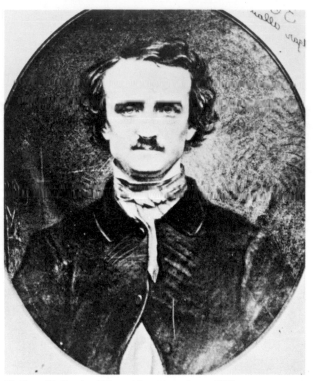

Mathew B. Brady, *Edgar Allan Poe,* about 1845

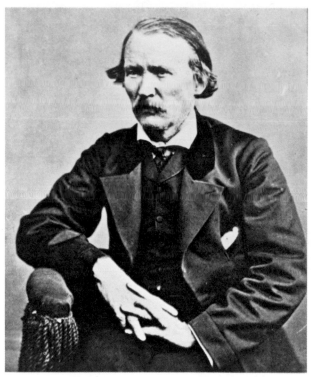

Mathew B. Brady, *Kit Carson,* about 1860

15
ILLUSTRIOUS AMERICANS
Mathew B. Brady

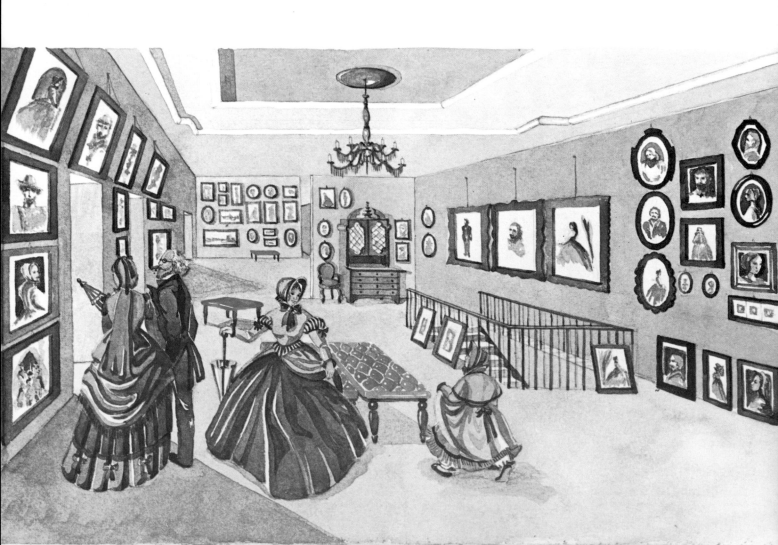

Samuel F. B. Morse, portrait painter and the ingenious inventor of the telegraph, brought photography to the United States. Morse was in Europe when Daguerre's discovery was announced, and he sent a letter from Paris to the New York *Observer* in April 1839 rapturously describing the images that Daguerre himself had shown him.

After his return to New York later that year Morse opened a studio in which he not only produced much sought-after photographic portraits, but where he also started what may have been the first photography school in the world. For a fee ranging from twenty-five to fifty dollars, he would provide the equipment and supplies necessary to master the new art.

After taking his course, many of Morse's students went on to open studios of their own in most major American cities. Among them, New York's Mathew B. Brady held a position of special importance. Born in 1822, Brady worked at all sorts of jobs—from errand boy to miniaturist—before going into photography. In 1844 he opened a photographic studio on Broadway, a perfect central location, and the beauty of his daguerreotypes quickly earned him popular and critical acclaim. Realizing that his fame would be proportionate to that of the people he photographed, Brady cultivated the society of exciting personalities. In the spring of 1845, aware that Andrew Jackson was dying at his home in Nashville, Tennessee, Brady sent one of his assistants to capture the former president's face forever on a daguerreotype. Jackson was one of the best-known and best-loved men in America, and, after his death, engravings taken from Brady's daguerreotype were published in all the newspapers of the day, further spreading Brady's renown.

From that moment on, Brady's work would be inextricably tied to American history, for anyone of any importance had to have his portrait done by Brady. Among the thousands of portraits he left behind are those of the melancholy Edgar Allan Poe (author of poems and well-known mystery tales), the majestic poet Walt Whitman, the legendary Indian scout Kit Carson, the circus owner P. T. Barnum, and many others.

On February 27, 1860, the almost unknown presidential candidate Abraham Lincoln passed through New York on his campaign and was brought to Brady's studio to be photographed. Brady's portrait captured the stern, preoccupied features that any voter would want to see in any leader of the nation, especially at a time when the Southern states were preparing to secede from the Union. Reproduced and distributed in thousands of campaign lockets, this image contributed to Lincoln's election as president, as Lincoln himself later admitted.

Shortly thereafter, the United States was plunged into the tragic Civil War, another event Brady and his photographers would witness and faithfully record.

Mathew B. Brady, *Abraham Lincoln,* February 27, 1860

Mathew B. Brady, *Jenny Lind,* about 1850

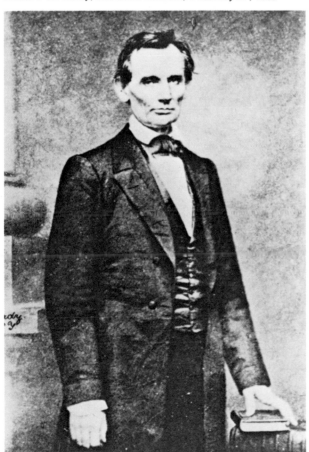

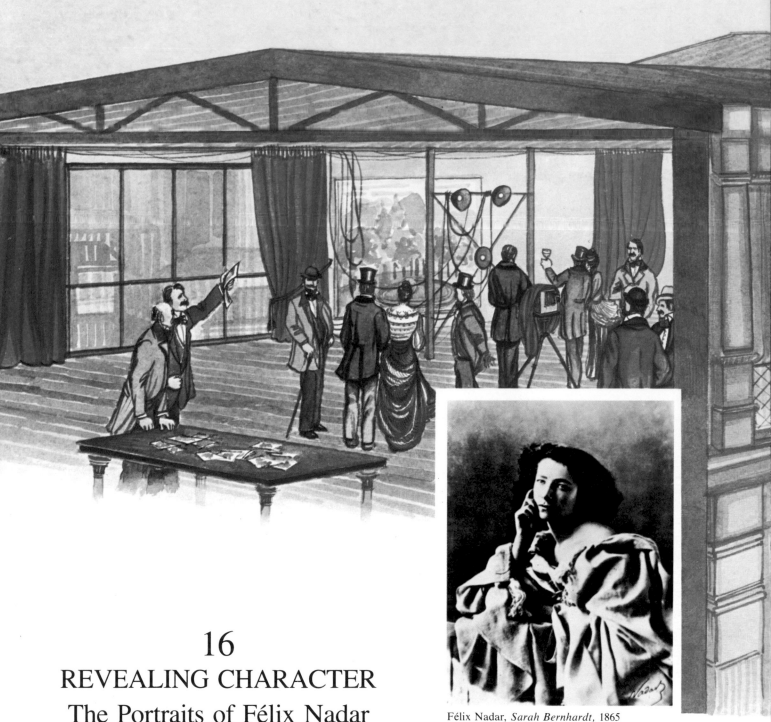

Félix Nadar, *Sarah Bernhardt*, 1865

16
REVEALING CHARACTER
The Portraits of Félix Nadar

Just as in New York and Washington, D.C., Brady photographed illustrious Americans working to build a great nation, so in Paris Nadar, a staunch Republican opposed to the reign of Napoleon III, made portraits of the artists and intellectuals who enlivened the cultural life of the great French capital. Nadar's real name was Gaspard Félix Tournachon, but his friends, a group of eccentric vagabond artists known as Bohemians who lived in the narrow streets of the Latin Quarter, saddled him with the nickname.

Nadar was born in 1820. In the difficult years of his early youth, he tried without much success to launch careers in journalism and literature. In 1846 he decided to abandon these pursuits in favor of caricature—exaggerated

cartoon drawings poking fun at celebrities—an art not only better suited to his humorous temperament, but also more profitable. Soon he became one of the most popular caricaturists of his time.

In 1852, Nadar set out to create the "Panthéon Nadar," a series of caricatures of the most illustrious "poets, novelists, historians, essayists, and journalists." As David O. Hill had done in Scotland, Nadar made photographs as models for his sketches, inviting the most prominent figures in France to pose for him.

Nadar soon showed a superior talent for making photographic portraits of important individuals. He opened a photographic studio in 1854 that promptly became a favorite among Parisians and foreign visitors alike. Although his

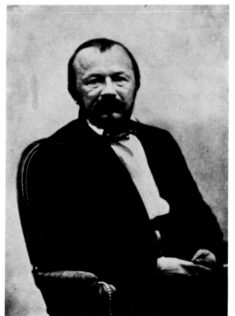

Félix Nadar, *Gerard de Nerval*, about 1853

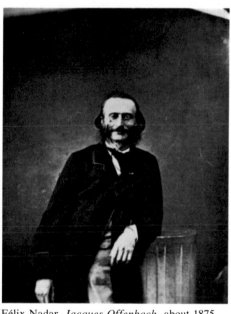

Félix Nadar, *Jacques Offenbach*, about 1875

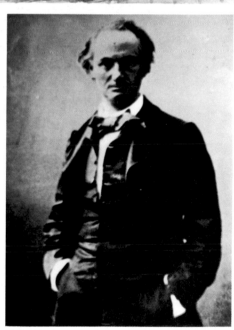

Félix Nadar, *Charles Baudelaire*, 1862

sitters were carefully posed—usually in three-quarter view—they appear relaxed and natural, as if captured in the midst of conversation. Nadar respected the artistic effects he could achieve with the camera—graceful lines and the contrast of light and shadow, for example—but, even more, he took pleasure in photography's ability to give a picture of the personality as well as the appearance of an individual.

Nadar was therefore one of the few photographers in the medium's early history who realized that the discovery of photographic technique was merely a mechanical discovery: to transform faces into portraits, the photographer not only had to be intelligent, but also talented.

Eager to unveil the inner character of his subjects, Nadar experimented with artificial lighting. Once he could control light without the delays caused by varying levels of sunlight, Nadar skillfully captured in his portraits the moment most representative of his subject, drawn from the countless facial expressions offered to the camera.

Thus, the photograph of the poet Charles Baudelaire shows, "the strangeness of his gaze" as well as "the delicacy and infinite discernment of his heart." The portrait of the eccentric poet Gérard de Nerval reveals the tragic restlessness of his life, while the picture of actress Sarah Bernhardt radiates intense beauty.

17
NEW PERSPECTIVES
Félix Nadar

Nadar not only made striking achievements as the photographer of intellectuals; he also demonstrated for the first time photography's infinite versatility when joined to the most recent scientific and technological discoveries of the day. In fact, the most famous pictures Nadar made using artificial light were not his portraits, but his photographs of Parisian sewers and catacombs, inspired by descriptions in Victor Hugo's novel *Les Misérables*.

Working long and hard throughout 1861, Nadar had to overcome considerable obstacles: for example, he had to set up unwieldy power generators on the street and run cables from them down through the manholes to the system of lights. Because of the long exposure times he had to use, Nadar could not pose live models; he set up dummies pulling carts or performing other tasks. The blank looks on the mannequins' faces, lit by artificial lights, make the scenes seem eerie, but Nadar never indulged in the macabre. The nearly one hundred pictures he managed to make under these conditions reveal the secret underground passageways that carry the refuse of the living and the remains of the dead.

Some years earlier, Nadar had conceived an even more astonishing project. In the autumn of 1858, aloft in a hot-air balloon high over Paris,

Félix Nadar,
*In the Paris
Catacombs,* 1861

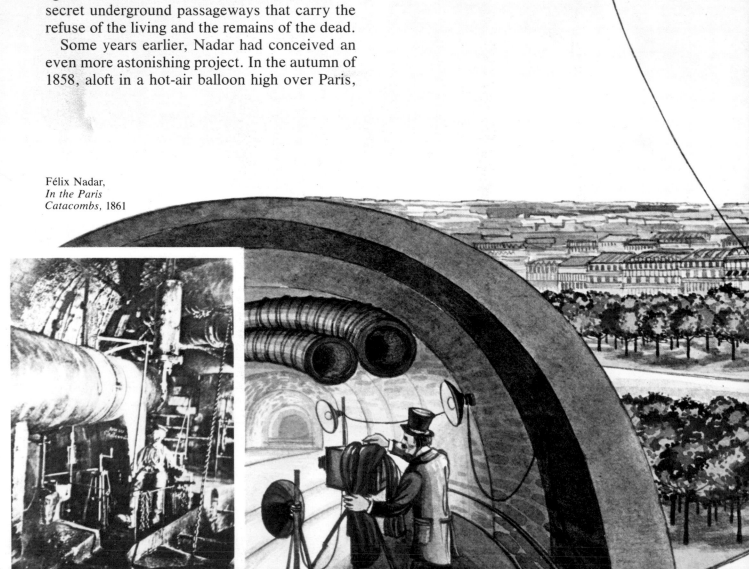

Nadar made what is considered to be the first aerial photograph. Filled with enthusiasm for this new adventure, he and other distinguished representatives of science and culture founded, on July 6, 1863, the "Society for the Encouragement of Aerial Locomotion by Means of Heavier-than-Air Devices." In order to finance this costly venture, Nadar built "Le Géant," the world's largest balloon, and offered balloon flights to the public in its double-decker basket. Unfortunately, during the second flight of this enormous contraption, Nadar had a serious accident, and, although he recovered, he gave up his airborne escapades.

In 1870, however, Nadar was able to enlist his balloon expertise in service to France during the Prussian army's siege of Paris. Together with the technicians who had helped him on his previous adventures, he constructed and commanded a company of balloons that observed German military positions and insured communication between Paris and the outside world. These message deliveries by balloon marked the beginning of airmail service. Nadar lived to see the final conquest of the skies by the airplane, the heavier-than-air device to which he had devoted so much of his energy. He died in 1910, the year after Louis Blériot crossed the English Channel in his monoplane.

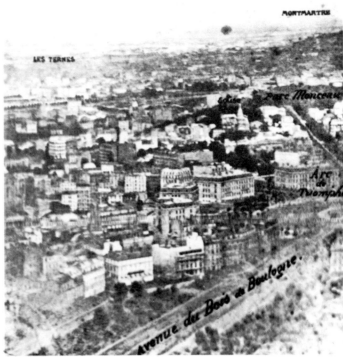

Félix Nadar, *View of Paris*, dated 1858

First Pictures from Distant Lands

18
THE TREASURES OF ANCIENT EGYPT
Maxime Du Camp

The rediscovery of the ancient civilization of Egypt, whose pharaohs filled the Nile Valley with royal tombs and pyramids thousands of years before the birth of Christ, came when Napoleon sent a military expedition into that country in 1798. Near the small town of Rosetta, a captain in the Napoleonic army found a stone plaque bearing an inscription in three kinds of script. One of them was Greek, and by comparing it to the two kinds of hieroglyphs on the stone, the French Egyptologist Jean-François Champollion succeeded in deciphering hieroglyphic writing in 1821. This breakthrough made it possible to reconstruct the lost history of ancient Egypt from the records preserved on thousands of stones and documents. When photography was invented, scholars immediately recognized that its ability to copy these writings could greatly assist their Egyptian studies.

In the autumn of 1839, the painters Horace Vernet and Frédéric Goupil-Fesquet successfully

produced the first daguerreotype of the pyramids, using an exposure of roughly fifteen minutes. But since daguerreotypes could not be reproduced, illustrations had to be copied from the photographic images by professional engravers.

In the next few years many travelers attempted to make daguerreotypes of the sphinxes, obelisks, and temples. One of them, Nadar's friend Gérard de Nerval, returned with only "two or three photographs . . . because the necessary chemical components had decomposed due to the hot climate." Apart from these problems, the daguerreotype continued to be less than ideal for this kind of project because of its inability to yield multiple copies. Thus, Maxime Du Camp, an author sent to Egypt by the French Ministry of Education, decided to use the process patented by Talbot and greatly improved by French photographers. The calotype was "a long, meticulous process. . . . However strong the lens and chemicals used to obtain the image,

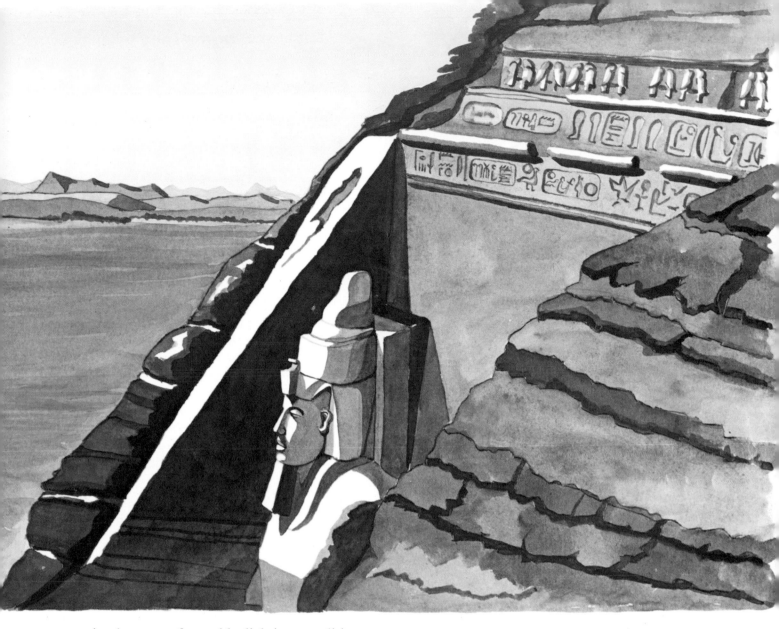

even in the most favorable lighting conditions it required an exposure time of at least two minutes." Nevertheless, with paper negatives, copies could be made. During the three-year journey, upon which he was accompanied by the writer Gustave Flaubert, Du Camp took more than 200 photographs. When no human figure is present to suggest the dramatic scale of the monuments, his views suggest the feeling of desolation and mystery that surrounds these age-old stone colossi, half-buried by the sand.

The selection of 125 calotypes that Du Camp managed to bring back to Europe despite endless problems appeared as *Egypt, Nubia, Palestine, and Syria. Photographic Pictures Collected in the Years 1849, 1850, and 1851.* Du Camp's volume was followed by books by Félix Teynard and others who, less bound by the rigid intentions of archaeological documentation, achieved even better artistic results. It would be another ten years before the discovery of new techniques would permit the general public to own photographic albums of artworks and foreign scenes, but Du Camp's volume of photographs established a means of communication for photography that profoundly changed man's vision of the world and of himself.

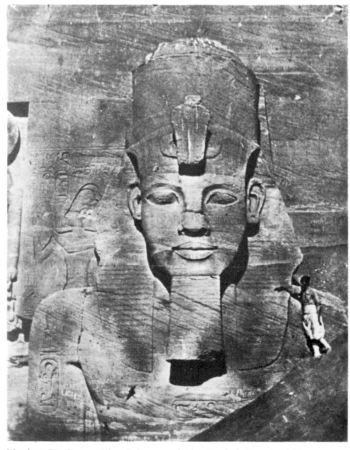

Maxime Du Camp, *The Colossus of Abu Simbel, Egypt,* 1850

19
THE WET COLLODION PROCESS
Multiple Prints

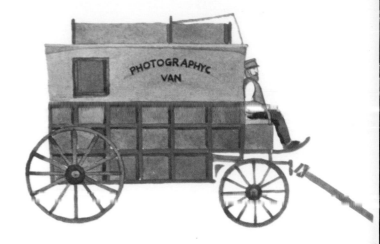

The invention of the wet collodion method marked the beginning of one of the most exciting periods in the history of photography. From 1839 to 1850, photographic technology had seen no significant innovations and remained essentially unchanged. The use of more sophisticated chemical products and the adoption of sharper lenses allowed for the gradual reduction of exposure times, sometimes to as little as a few seconds. These improvements, however, still did not advance photography beyond the limits of the daguerreotype and calotype.

Although the daguerreotype possessed great clarity, it could not be reproduced and it had an annoying glare. It was primarily a parlor showpiece, encased in its precious little velvet box to protect its extremely sensitive surface from scratches. The calotype cost less and could be copied from the original negative, but its paper negative never gave the same sharp-edged details as the daguerreotype.

Various researchers had tried to use glass plates for the negative, hoping to combine the calotype's advantages with the daguerreotype's precision. The problem was to find a chemical coating for the glass plate—called an emulsion—that could be sensitized in such a way that the image would stick to the glass. Frederick Scott Archer identified the substance collodion as the best emulsion and in 1851 published his method, which entailed a far more complicated process than any of the previous systems.

The glass plate was first covered with a uniform thickness of collodion in which potassium iodide had been dissolved; the plate was then dipped, and thus sensitized, in a silver nitrate solution. Once prepared in this way, the plate had to be used within fifteen minutes, while the collodion was still wet, because if it was allowed to dry it would lose most of its light sensitivity.

Once an exposure was made—it now required only about a few seconds to a minute—the plate was developed in pyrogallic acid and fixed, usually with potassium cyanide.

Although these delicate operations carried out immediately before and after an exposure made the glass negative relatively inconvenient, the collodion process guaranteed remarkable quality in the final print.

Traveling in specially constructed photographic wagons, photographers began to adapt the collodion method for use out of doors. Besides being able to deliver for the first time accurate visual reports from battlefields, photographers could now make landscape views and panoramas with exquisitely sharp details. Thus, photography as a documentary medium and photography as an art advanced hand in hand.

1. Pouring the collodion and sensitizing the glass plate
2. Inserting the plate in the camera and taking the photograph
3. Developing and fixing the plate
4. Negative obtained on the plate
5. Placing the glass negative on a sheet of sensitized paper
6. Exposing to the light the negative on the sensitized sheet of paper
7. Developing and fixing the sheet of paper
8. Finished photograph

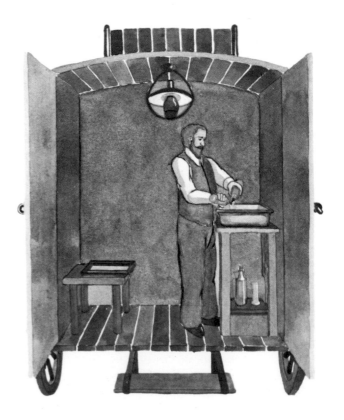

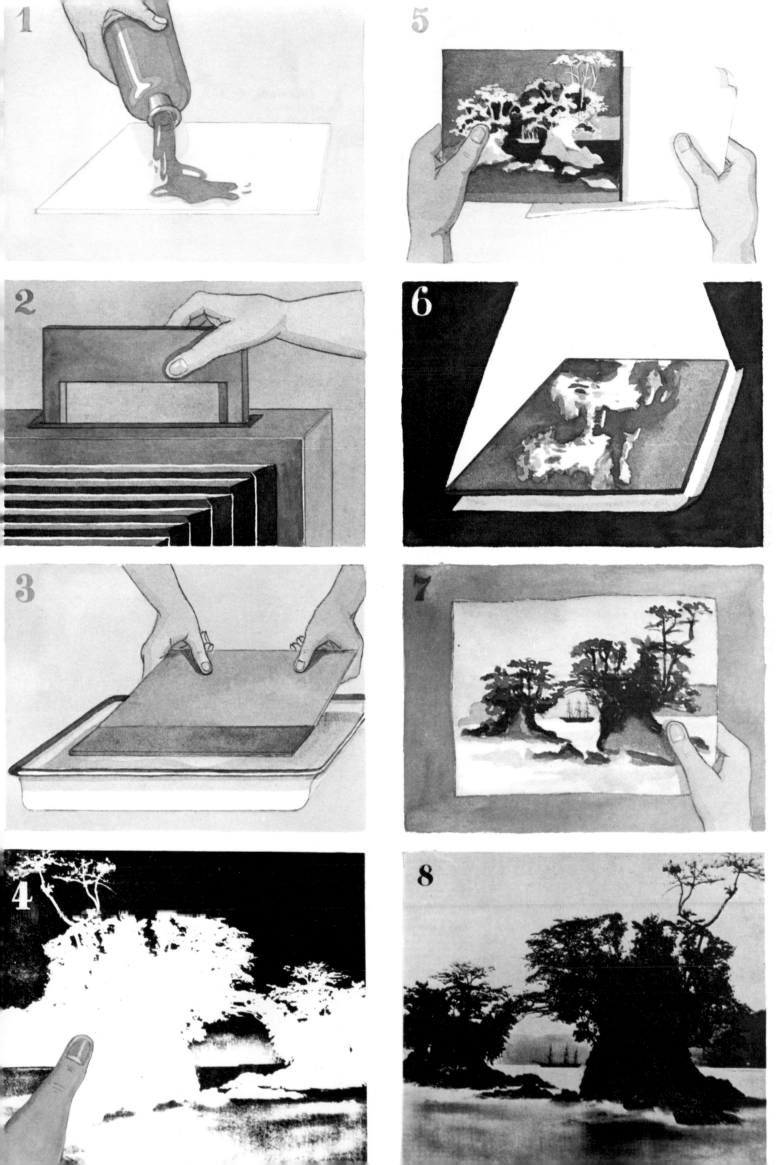

20
THE FIRST PHOTOGRAPHIC ALBUMS
Francis Frith

In the second half of the nineteenth century, the lively cultural interest Europeans showed in Egypt paralleled the growing interest of the great powers in the Near East, where the might of the Turkish Ottoman Empire was undergoing an irreversible crisis. One archaeological expedition followed another in swift succession, and with these came the journeys of the nobility and wealthy middle class, for whom a tour of the Near East had become a pleasant pastime and a coveted mark of distinction.

In scientific circles and in sophisticated drawing rooms, the pictures that visitors continued to bring back and distribute at home fueled interest in exotic places. Among these, the work of the English photographer Francis Frith was very important. Frith turned to photography late in his life, after working at various other occupations, but within a short time he became one of the most active advocates for the commercialization and popularization of photography. Encouraged by results recently obtained by his countryman Roger Fenton in photographing the Crimean War, Frith decided to use on his first trip to Egypt, in 1856, the "wet collodion" process invented a few years earlier. Although the wet collodion method was even clumsier than earlier processes, it yielded high-quality photographic prints infinitely superior to those struck from the paper negatives used by Maxime Du Camp and Félix Teynard.

Frith traveled along the banks of the Nile River in a wicker carriage that served as a darkroom on wheels. To get the best possible pictures he carried no less than three cameras: a standard 8 x 10-inch studio model, a 16 x 20-inch version, and a special camera with two lenses for making stereoscopic pictures. When viewed through a device called a stereoscope, these double photographs gave the illusion of three dimensions, further heightening the armchair traveler's sense of being present at the scene.

Despite the problems inherent in the method, problems that were aggravated by the intense desert heat, the results were successful enough to make Frith decide to mount another campaign the following year. This time he visited Palestine.

The publication of a selection of seventy pictures, collected into two volumes entitled *Egypt and Palestine Photographed and Described,* required the printing and pasting of about 140,000 original photographs. The albums thrilled the Victorian public, and along with the stereoscopic pictures they became extremely popular.

In 1860 Frith founded Frith & Co.,in Reigate, England. It soon became one of the most important firms in the production and marketing of photographic albums containing views of favorite tourist sites. Few people at that time could afford to travel, but many began to learn of the marvels of the world through these images.

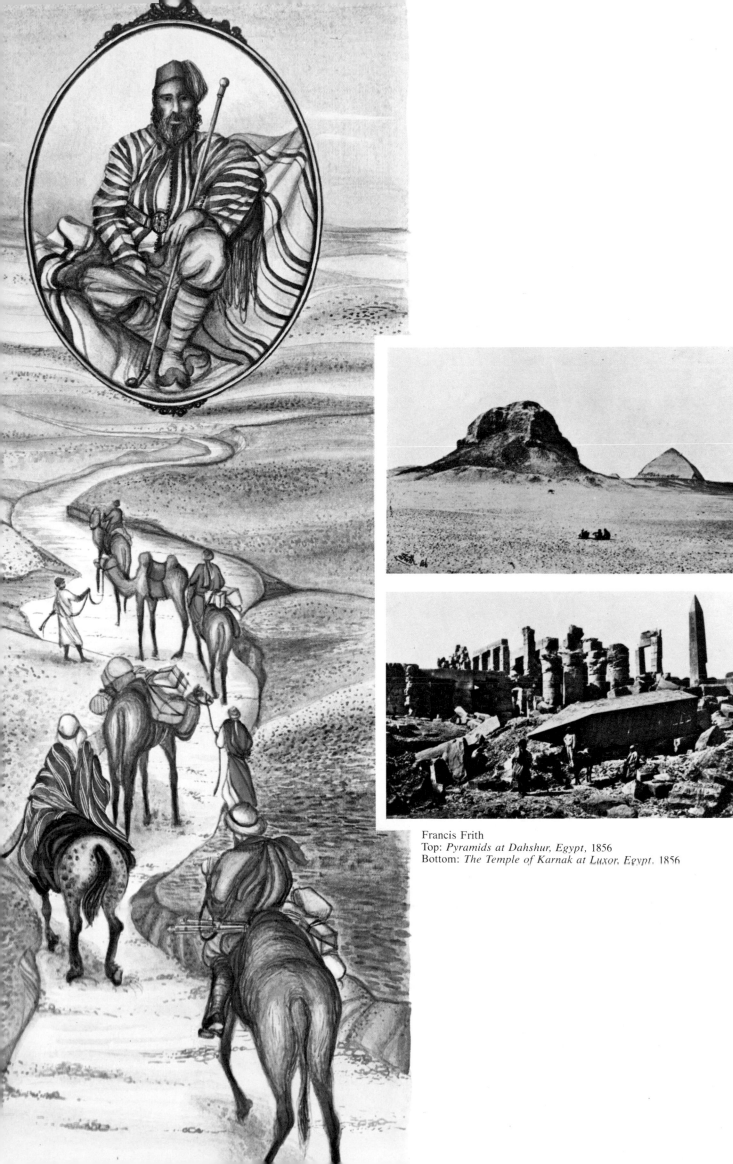

Francis Frith
Top: *Pyramids at Dahshur, Egypt,* 1856
Bottom: *The Temple of Karnak at Luxor, Egypt,* 1856

21
THE CRIMEAN WAR
Roger Fenton

In 1853, Czar Nicholas I of Russia, trying to take advantage of the crisis in which the Ottoman Empire was floundering, invaded the principalities of Valaccia and Moldavia at the mouth of the Danube, thus threatening Turkey itself. Alarmed by these expansionist policies, France and England united with the Kingdom of Sardinia to launch a rearguard attack on the invading army, landing troops on the Crimean peninsula and laying siege to the city of Sebastopol. Several photographers in England decided to document the faraway war, the first time such an undertaking had ever been attempted.

The Agnew Brothers, picture publishers in Manchester, England, sent to the front Roger Fenton, who had become one of the most respected photographers in England. Working on behalf of the Royal Photographic Society in the British Museum, Fenton had already had experience photographing statues, ancient remains, and rare manuscripts for use by scholars.

Fenton also had to his credit some splendid calotype views taken out of doors in Moscow, but for the Crimean mission he decided to use the wet collodion method. In order to develop the negatives on the spot, he built a totally enclosed wooden wagon which contained the chemicals and other apparatus necessary for the process. In March 1855, together with his assistant Marcus Sparling and a workman, he landed at the port of Balaclava on the Black Sea. Here, at the allies' logistical center, sailing ships, wag-

ons, cannon, and provisions sprawled beneath an arid mountain.

Fenton began his work, basing his photographs of battle scenes on the paintings he knew and their proven, rigid compositions. Perhaps because of his reliance on old-fashioned methods, he produced images that succeeded as standard compositions, but failed as reports of the real-life face of war as it showed itself in the tragic suffering and death of soldiers. Most likely, conditions limited his subject matter—the plates required several seconds of exposure time, which made recording the battles actually in progress difficult and dangerous, especially since the Russian cannon were taking easy aim at the highly visible lens on the "Photographic Van." Fenton no doubt preferred to stay far behind the front lines, where he could photograph the officers in full regalia, the orderly camps of the regiments, and the nurses who treated false wounds improvised on the spot for the camera's benefit. With his image of *The Valley of the Shadow of Death*, littered with the cannonballs that had massacred the light cavalry brigade. Fenton felt his mission was complete and preferred to return home. The desperate attack had been bloodily repelled by the Russians, and the June heat had caused a terrible outbreak of cholera among the troops.

Credit for documenting the final catastrophe of the war—the fall of Sebastopol on September 8, 1855—belongs to two adventurous photographers who had just arrived from the island of Malta: James Robertson, formerly chief engraver at the Constantinople Mint, and Felix Beato, a naturalized British citizen born in Venice. The two worked well together and went on to document grief and suffering on other faraway battlefields.

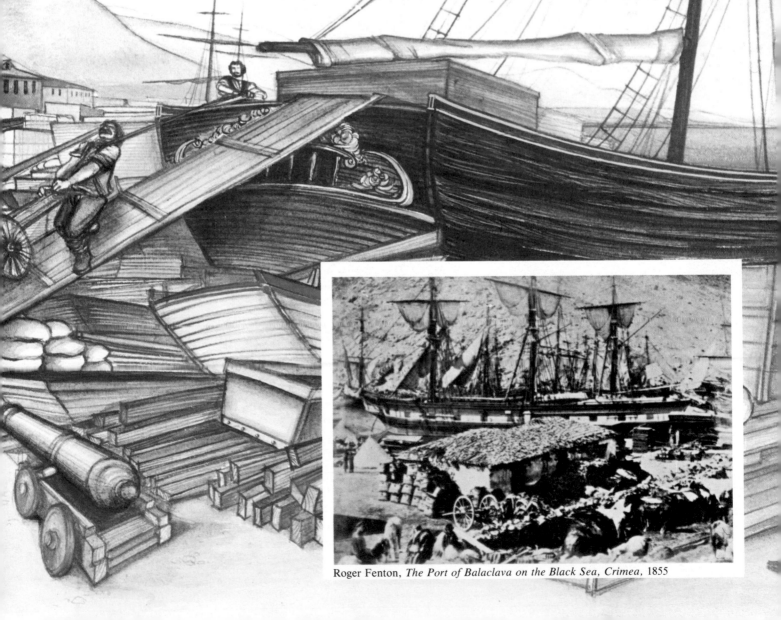

Roger Fenton, *The Port of Balaclava on the Black Sea, Crimea*, 1855

22
PHOTOGRAPHER ON THE BATTLEFIELD
Felix Beato

After the Crimean War, James Robertson and Felix Beato went to Egypt to make a series of views, still much in demand and widely sold in Europe.

Approaching composition with originality, Beato placed the ruins of the pharaohs and the mosques and palaces of Cairo on the horizon line and surrounded them with immense space. With great skill and naturalness, he included men and animals in his photographs, subjects seldom found in images at the time.

Beato and Robertson soon moved on. In 1857 the "Great Revolt" of the Sepoys—the native soldiers in India—erupted against English occupation. The two photographers decided to follow Sir Colin Campbell's troops, which had been sent from Great Britain to quell the mutiny. The most important episode of the war was the siege of Lucknow, one of the major centers of resistance. Here, amid the devastating spectacle

of a remarkable city buried under the bodies of dead men, Beato presented for the first time in photography the corpses of soldiers fallen in battle.

But the wartime incident that Beato described with the greatest dramatic impact took place in China a few months later. In the early nineteenth century, hoping to profit from the great decline of the once-powerful Chinese empire, European powers sought to establish trading concessions and other privileges within Chinese territory. In 1856, after the Chinese stormed and boarded a ship flying the English flag, a new crisis developed. The English, aided by the French, turned the situation to their own advantage in 1858, when they forced China to sign treaties extending even more power to the Europeans.

Beato gave a dramatic documentation of that colonial enterprise. His photographs follow the

course of the war, from the bastions all the way to the tragic scene inside the forts, when the Western forces finally struck down and killed the defenders.

Beato's journey in the Far East later took him to the still mysterious country of Japan; there he produced his most serene views—Japanese gardens and portraits—finally setting up commercial ventures in Rangoon, Burma, before his death about 1907.

In the history of photography Beato is remembered for having shattered the falsely heroic image of war held by those fortunate enough never to engage in battle. Photographs refuted the idea that soldiers died painlessly, with a triumphant smile on their lips.

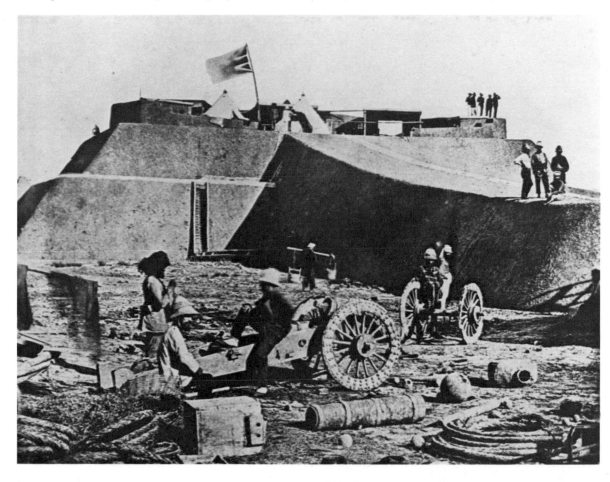

Felix Beato
Top: *Fortifications of Taku, China,* August, 1860
Left: *Canton,* April, 1860
Directly above: *Yedo [modern Tokyo], Japan,* about 1862

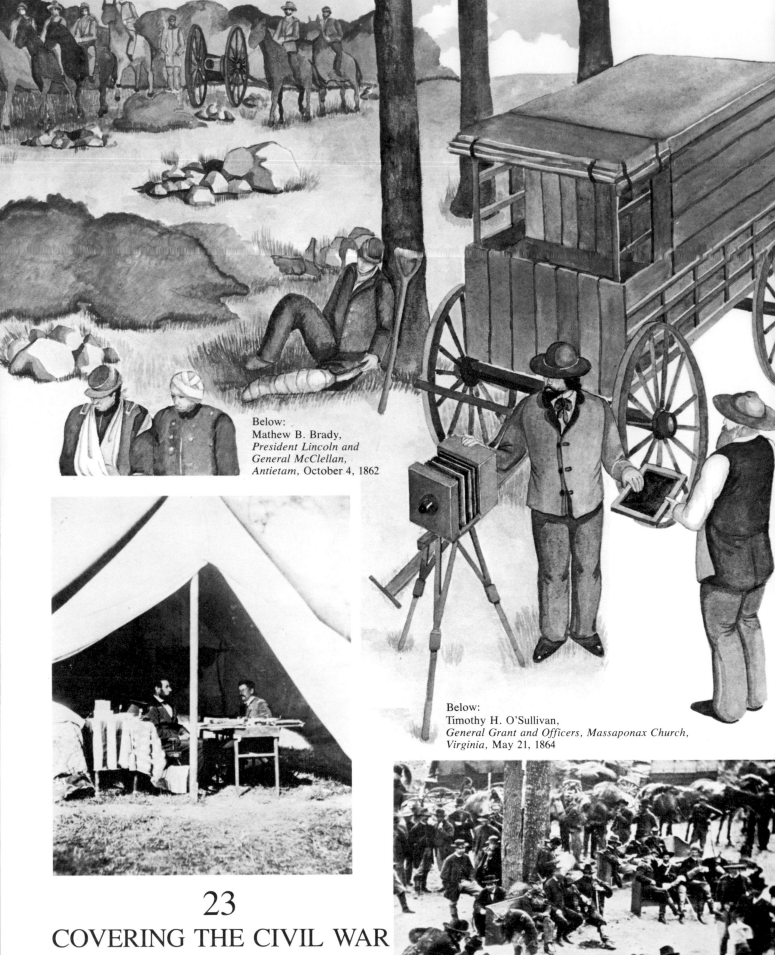

Below:
Mathew B. Brady,
*President Lincoln and
General McClellan,
Antietam,* October 4, 1862

Below:
Timothy H. O'Sullivan,
*General Grant and Officers, Massaponax Church,
Virginia,* May 21, 1864

23
COVERING THE CIVIL WAR
The Brady Photographers

In the 1850s and 1860s growing tension between
the North and South divided the United States.
The agricultural economy of the Southern states
depended on slave labor; the Northern states,
increasingly industrialized, opposed slavery. In

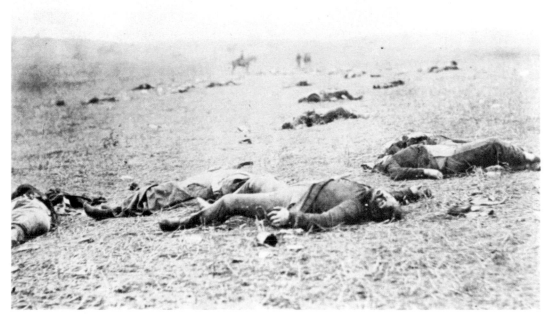

Timothy H. O'Sullivan. *A Harvest of Death, Gettysburg, Pennsylvania,* July 5, 1863

1860, the entrance into the Union of California, Oregon, and Minnesota, all antislavery states, along with the political position of the newly elected president, Abraham Lincoln, brought the country to a crisis.

In order to preserve their economic structure, the Southern states chose to separate, or "secede," from the rest of the country and form the independent Confederacy, with Jefferson Davis as president. These developments, together with the Confederate bombardment of Fort Sumter, South Carolina, which the Federal government had refused to surrender to the Confederacy, sparked the outbreak of the Civil War.

Mathew B. Brady, who had photographed many of the country's great men in the privacy of his studio, now took his equipment to the battlefield to record their actions in war. With President Lincoln's permission to follow the army, Brady and one of his assistants, Timothy H. O'Sullivan, covered the first major battle of the war on July 21, 1861, at Bull Run, in northeastern Virginia, just outside of Washington, D.C. Against all expectations the Confederate troops routed the Union army of General Irvin McDowell. The chaotic retreat of panicked Union soldiers swept up even the courageous photographers, who, after fleeing the field, made their way back to Washington, bringing with them photographic documentation of the encounter.

In order to cover the ever-expanding front lines, Brady began to use as many as twenty teams of photographers, spending what was then an astronomical sum of money. Because Brady published all of these photographs under his own name, it is difficult to identify which of

his photographers made which pictures. Brady himself no doubt took those of the highest-ranking Union officers because these images bear the mark of his inimitable style. The most striking of these is a photograph of President Lincoln and General George McClellan posed in the army's field headquarters at Antietam; inside the tent the president's stovepipe hat and candles for the late-night vigil stand on a table draped with the Union flag.

In the second year of the war, another Brady assistant, Alexander Gardner, left Brady's studio and began one of his own, in order to protect his rights to the photographs he had taken. O'Sullivan, then little more than twenty years of age, followed Gardner and continued to photograph the war. O'Sullivan produced the most intense images of that period. At Gettysburg, in July 1863, after three days of fighting in which the Union troops under General George Meade finally prevailed, O'Sullivan took the well-known photograph *A Harvest of Death.* In the picture, the blurred horizon of the plain in the background focuses attention on the body of a dead soldier in the foreground, a tragic symbol of war's absurdity. The battles, the destruction, and the deaths continued until 1865, when the Confederate capital, Richmond, Virginia, fell.

In the new age that dawned once the United States returned to peacetime Brady ceased to be a major figure. The colossal task of documenting the Civil War had left him physically and emotionally exhausted. The job of following the construction of the transcontinental railroad and the discovery of the wild Far West he left to his younger pupils Gardner and O'Sullivan.

24

DISCOVERING THE WEST

Carleton Watkins, Timothy H. O'Sullivan, and William Henry Jackson

Twelve years after the 1849 Gold Rush, which had fired the dreams of thousands, California was in many ways an earthly paradise uncontaminated by man, an ironic contrast to the war-torn states in the East.

In 1861 Carleton Watkins left San Francisco to photograph the Yosemite Valley; his images, with their monumental grandeur, balance of dark and light tones, and compositional harmony, expressed the beauty of that countryside—its mountains, waters, and plains. When the Civil War ended, Watkins's photographic skills were enlisted by Josiah D. Whitney, who together with Clarence King mounted an expedition to explore the territory around Yosemite and make the first maps of the area.

In 1867 King organized the Geological Exploration of the Fortieth Parallel, which, with Timothy H. O'Sullivan as photographer, completed in three years a comprehensive survey of the territory stretching across Colorado, Utah, and Nevada. King, a talented geologist, was one of the founding members of the Society for the Advancement of Truth in Art, and he showed enormous interest in photography because it could accurately render the smallest details of the landscape, and thus record its beauty better than painting.

The last expedition O'Sullivan accompanied was the one organized by First Lieutenant George M. Wheeler west of the one hundredth meridian. The photographs he made riding down the Colorado rapids—in a boat called *The Picture*—are truly spectacular, like those he took of the fourteenth-century Indian ruins in New Mexico's Canyon de Chelly.

After leaving the photographic studio he and his brother had opened in Omaha, Nebraska, William Henry Jackson began his own wanderings by taking pictures along the transcontinental railroad line, which was completed in 1869.

From 1870 until 1879, Jackson followed F. V. Hayden's expeditions into the as-yet-unexplored West. Jackson's most important pictures were those taken in Yellowstone. They succeeded so well in conveying the majestic beauty of the region that they helped influence Congress to declare it a national park. Jackson's most memorable image, however, is that of the Mount of the Holy Cross in the Rocky Mountains; it inspired a poem by Henry Wadsworth Longfellow and a painting by Thomas Moran.

In 1879, with the establishment of the United States Geological Survey, the government agency under King's direction charged with conducting explorations of the West, the adventurous period of discovery came to an end. Jackson spent the rest of his life—he lived to be ninety-nine years old—writing memoirs and painting pictures inspired by his memories of that heroic and unforgettable time.

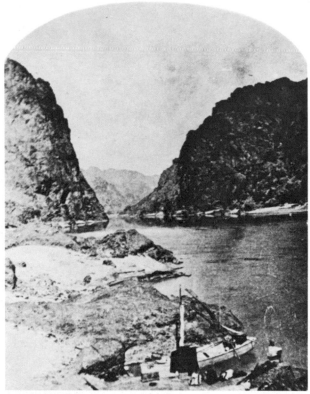

Timothy H. O'Sullivan, *Black Canyon, Arizona,* 1871

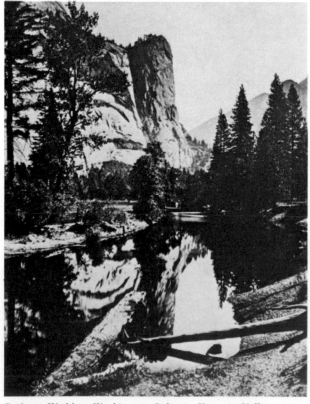

Carleton Watkins, *Washington Column, Yosemite Valley, California,* about 1866

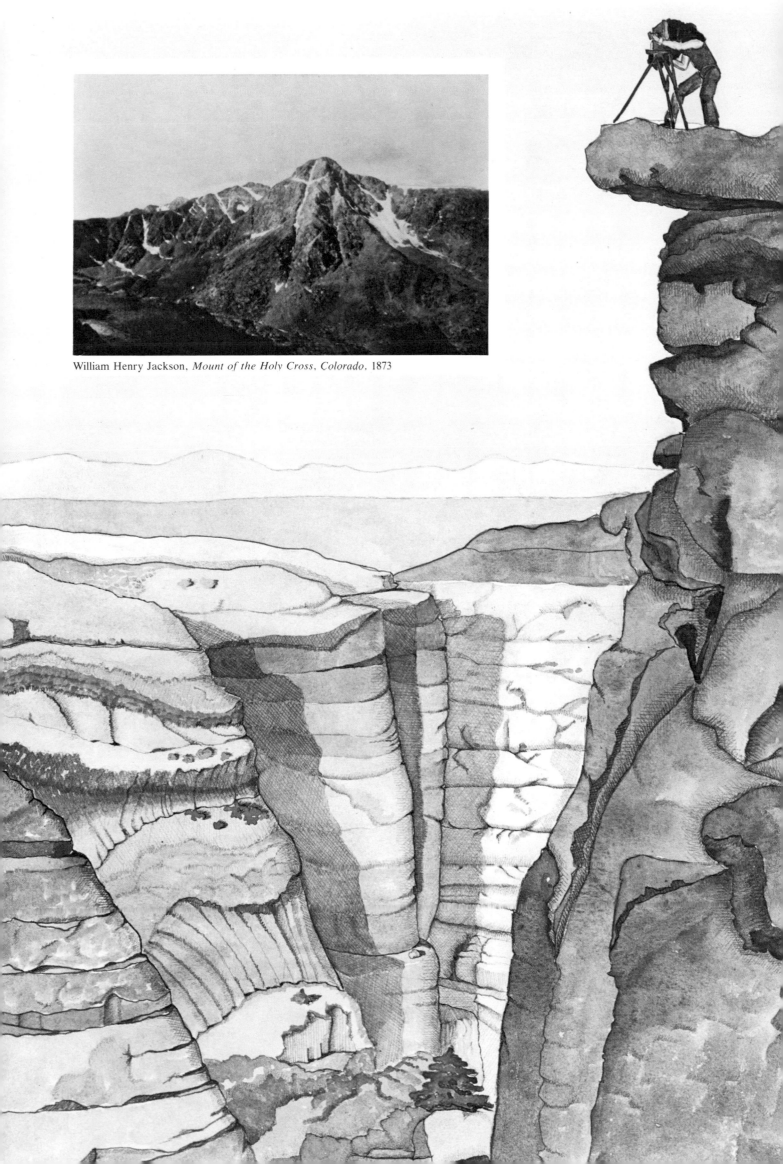

William Henry Jackson, *Mount of the Holy Cross, Colorado,* 1873

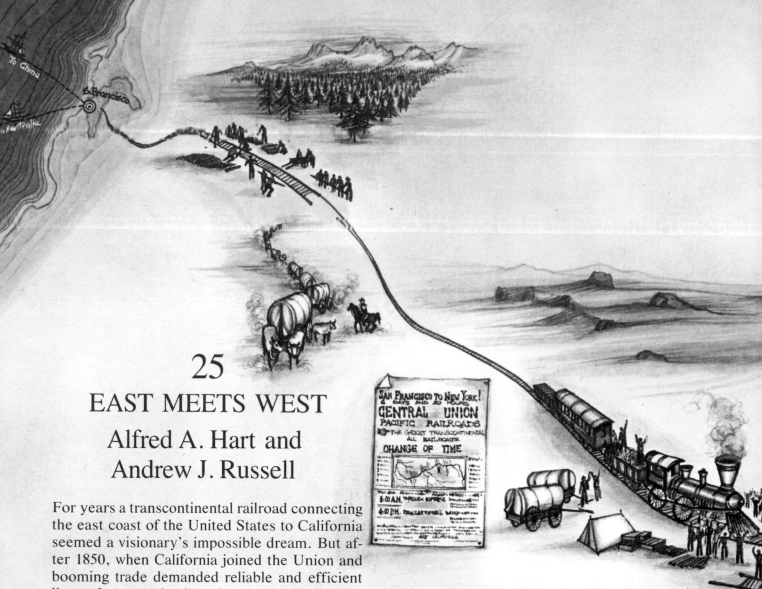

25
EAST MEETS WEST
Alfred A. Hart and
Andrew J. Russell

For years a transcontinental railroad connecting the east coast of the United States to California seemed a visionary's impossible dream. But after 1850, when California joined the Union and booming trade demanded reliable and efficient lines of communication, the construction of the railroad became a pressing necessity.

Indian attacks, mountains, deserts, and other hardships all complicated the journey from the Midwest to San Francisco. Four months of arduous traveling were required to make the overland route of almost 2,000 miles, mapped out by Joseph Walker in 1833. Land passage across the Isthmus of Panama—the canal had not yet been

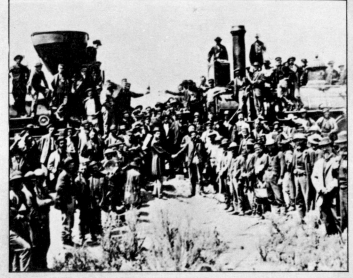

Andrew J. Russell, *Driving the Golden Spike, Promontory, Utah*, May 10, 1869

built—took one month and was both costly and risky because of the tropical climate. The sea route around the tip of South America was over 12,000 miles long and required six months of traveling. Only the railroad could join the two ends of the continent.

The surveys of Theodore D. Judah and Grenville Dodge ultimately solved the complex prob-

John Carbutt, *Railroad Westward*, 1866

lems of building a railroad across the Rocky Mountains and the Sierra Nevada, and investors immediately committed fortunes to carrying out the plans of these two enterprising engineers. On July 1, 1862, at the height of the Civil War, President Lincoln entrusted official responsibility for constructing the railroad to two companies, the Central Pacific Railroad and the Union Pacific Railroad. The legislative act did not specify the place where the two work gangs would finally meet, but it authorized payment to each company according to the number of miles of track each put into operation. A frantic race began between the two companies.

Like the Civil War, this undertaking was photographed day by day as it progressed. Alfred A. Hart documented the work of the Central Pacific, carried out by unskilled Chinese laborers who landed by the thousands in San Francisco. Hart preferred to place his camera at a distance from the action rather than move in close, and his pictures frequently juxtapose the thin railway line built by man's grueling labor to the sovereign majesty of the natural landscape. Always spectacular and carefully composed, his photographs depict the major stages of this difficult civil engineering project: the wooden trestles leading out of Sacramento, California, toward the first mountainous spurs; the winding roads

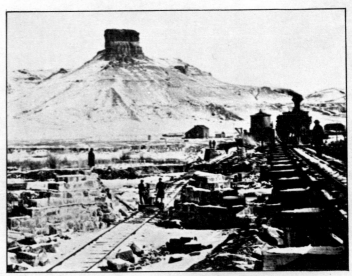

Andrew J. Russell, *Railroad Bridges and Citadel Rock, Green River, Wyoming*, 1867

carved into the living rock of the Sierra Nevada, mantled with snow piled higher than the locomotives; the broad curves of the tracks inside canyons sloping down toward the high plains of Utah.

In addition to Alexander Gardner and John Carbutt, the Union Pacific hired Andrew J. Russell, who had photographed the Union Military Railway during the Civil War and knew the region well. His photographs are often records, heavily detailed, seldom poetic. But Russell masterfully set against the huge mass of Cathedral Rock, the puffing locomotive "Jupiter 4-4-0," and he took the photograph most representative of this American adventure, the historic meeting of the two rail lines at Promontory, Utah, where the last rail was nailed to a crosstie with a golden spike on May 10, 1869.

26
THE EPIC TALE
OF THE NORTH AMERICAN INDIANS
Edward S. Curtis

After the completion of the transcontinental railroad and the government's geological expeditions, the white man's penetration of the West became more widespread, despite the determined resistance of the Indians, who wanted desperately to prevent the pioneers from establishing settlements. They knew that the cultivation of the prairie and the fencing off of grazing land, along with the construction of dozens of new towns, spelled the end of their nomadic hunting way of life, which was the source of their civilization.

The battle of Little Bighorn in 1876, when the Sioux and Cheyenne under Crazy Horse and Sitting Bull killed General George Custer and wiped out most of the Seventh Cavalry, was the last victory of the Indian tribes. Eventually they surrendered their way of life when they were forced to move to reservations. Soon, their authentic customs, ancient traditions, and most meaningful religious ceremonies began to disappear. After losing their freedom, they also began to lose their cultural identity.

At the beginning of the new century, the thirty-two-year-old Edward S. Curtis, who for some years had been taking pictures of a tribe around Seattle, witnessed the dissolution of that marvelous ethnic heritage, which still existed in the memory of the tribal elders. He conceived the grand project of documenting the life of all of the Indian populations west of the Mississippi from Mexico to Alaska.

Encouraged initially by the scientists he had accompanied on an expedition in the Bering Sea and supported by President Theodore Roosevelt (who had secured substantial financial backing for the project from the banker J. Pierpont Morgan), Curtis devoted himself to his work with love and respect for the Indian, attitudes seldom encountered among anthropologists and ethnologists, the scientists who studied "peoples." Because of his sympathetic approach, Curtis overcame the misunderstandings that had kept scientific researchers from reaching a true understanding of Indian culture. The Indians appreciated that Curtis's idea was to erect, as he explained, "an eternal monument to their race, and this caught their fancy. The news travelled from tribe to tribe." And no tribe wanted to be left out.

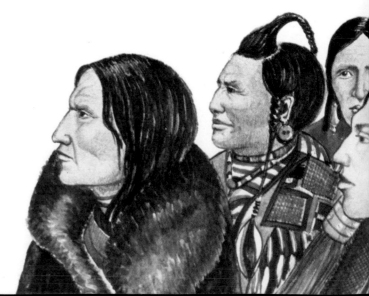

Year after year, Curtis moved among the eighty major tribes, living with them for months at a time, then often returning for additional visits. He recorded their habits, customs, and songs, and he photographed their most representative faces, their activities, tools, and ceremonies, all against the landscapes they had inhabited for centuries.

Curtis wanted to offer more than just scientific documentation. By reconstructing the past in his images, arranging traditional scenes in an epic dimension, he forever fixed and gave life to the deepest feelings of the Indian people. Instead of capturing the contrasts of strong light and shadow of the noonday sun, he posed his subjects against dark-toned sunsets, a fitting backdrop for a world that was quickly disappearing.

Curtis's work, finally completed in 1930, consists of twenty volumes of text with illustrations and twenty volumes containing only images, a total of more than 2,200 photographs selected from the 40,000 plates he had made in thirty years of work.

Curtis was not the only photographer to become fascinated by the Indian way of life. Adam Clark Vroman, a Los Angeles bookseller, also cast a sympathetic eye toward the American Indian in the Southwest. From 1895 to 1904 Vroman frequently visited the Hopi, Navajo, and Zuñi tribes, producing some 2,400 negatives. His photographs, less romantic than those of Curtis, combine drama and elegance in a superb documentary style.

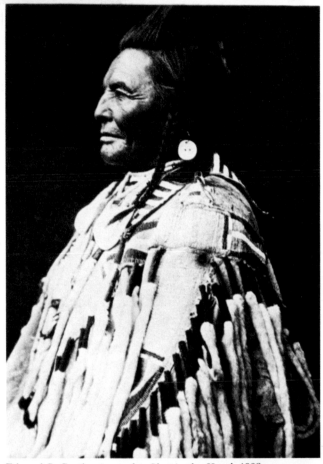

Edward S. Curtis, *Apsaroke, Shot-in-the Hand,* 1908

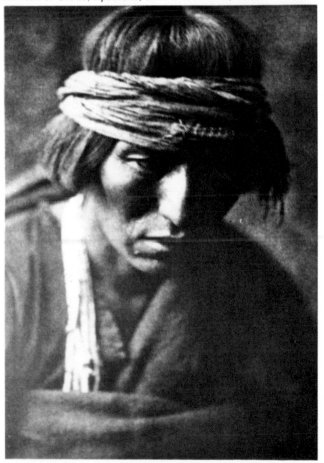

Edward S. Curtis, *Navajo, Medicine Man—Hastobiga*

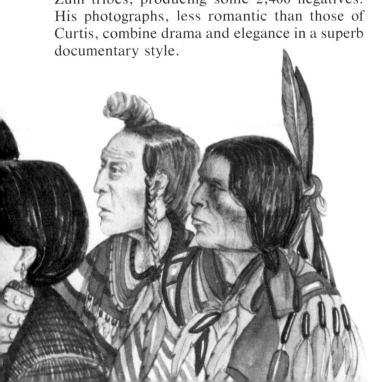

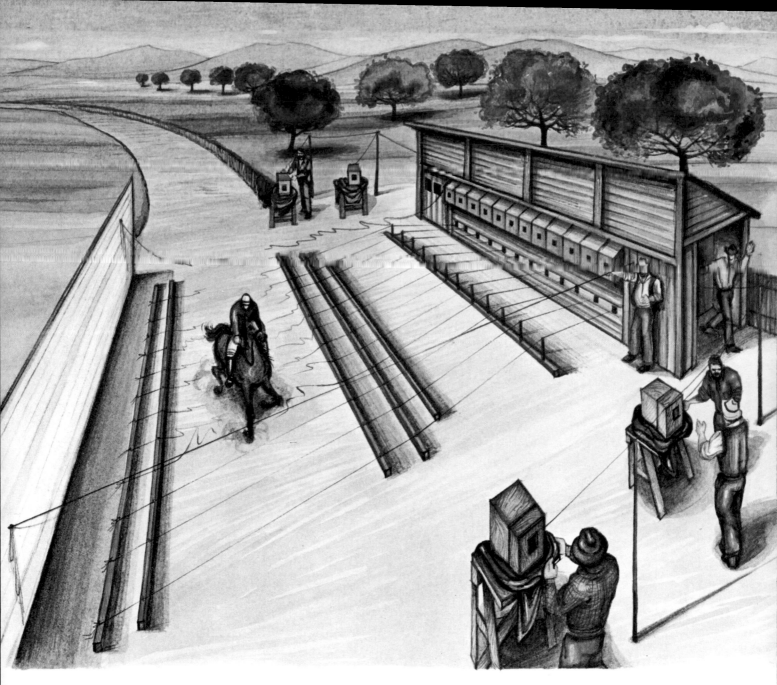

Photography Comes of Age

27
STOPPING TIME
Eadweard Muybridge

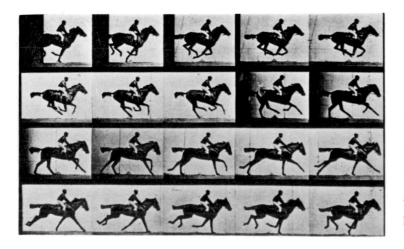

Above: The Sky Shade, Muybridge's
 rudimentary shutter, about 1867
Left: Eadweard Muybridge,
 Horse Galloping, Palo Alto, 1878

One of photography's chief characteristics has been its ability to fix a moment in time. Until the late nineteenth century, photographic cameras still had only one size aperture, the opening that regulates the amount of light passing through the lens. To make an image, photographers first had to judge the available light with the naked eye, then remove the lens cap, count the seconds thought necessary to obtain a well-exposed negative, and then replace the cap. If anything or anyone in front of the camera moved while the cap was off, the moving object would appear as a blur on the negative. For portraitists, stable shooting conditions could be created fairly easily in the studio, but for landscape photographers, timing was still an arduous problem: even if the scene contained no people, trees tossed in the wind, rivers and waterfalls flowed continuously, and clouds passed across the sky.

Carleton Watkins and Timothy H. O'Sullivan had explored some of these problems of outdoor photography, but it was Eadweard Muybridge who performed the most spectacular experiments for "stopping time." Arriving in San Francisco from England, Muybridge (who changed his name from Edward Muggeridge) achieved recognition for his photographs of Yosemite Valley made between 1867 and 1872, in which he managed to print for the first time even the shapes of moving clouds. To obtain this effect Muybridge had invented the "Sky Shade." This device, made from two thin, perforated wooden slats that could slide one over the other, made it possible to admit less light to the area of the negative that would register the sky; it was, in practice, a rudimentary shutter that allowed mechanical control over the time the film was exposed to light.

In 1873, the financier Leland Stanford engaged Muybridge to try to capture on film the galloping hooves of Stanford's horse Occident. After three days of experiments, Muybridge managed to produce an image of Occident in full stride, by controlling the shutter to snap at a speed of one five-hundredth of a second. Five years later, encouraged by his earlier success, Muybridge set up twelve cameras side by side, each 27½ inches from the next, with electrical shutters that worked at one thousandth of a second. The horse tripped the shutters by snapping twelve strings that stretched across the track. Muybridge's experiment proved that artists had inadvertently misrepresented reality when they painted galloping horses with all four feet extended and off the ground.

Under the patronage of the University of Pennsylvania, Muybridge carried out further studies in the motion of men and animals. In 1880, using a camera he called the zoopraxi-

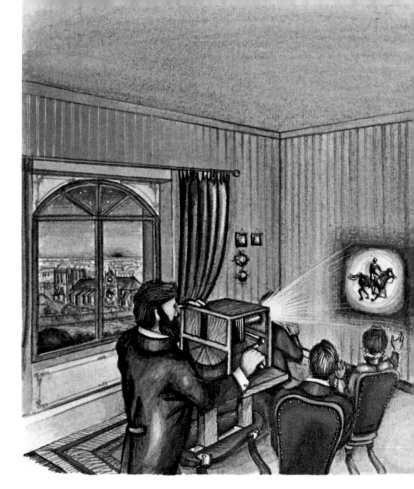

scope, which projected light through rapidly spinning single photographs mounted on a circular glass plate, he showed images *in motion*. This instrument would later be refined in Paris by Étienne Marey, and by Louis and Auguste Lumière. On the evening of December 28, 1895, the Lumière brothers projected their moving pictures before the amazed customers in a Paris cafe. Muybridge's photographic studies of motion gave life to a new language, the language of the moving image—motion pictures.

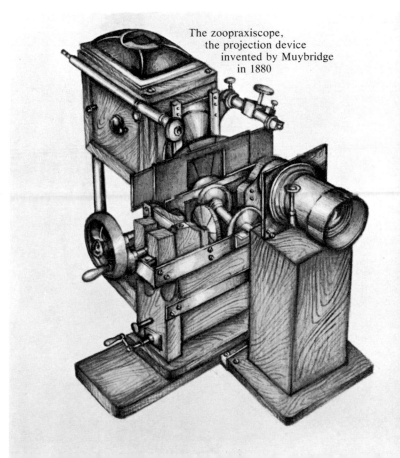

The zoopraxiscope, the projection device invented by Muybridge in 1880

28
A PHOTOGRAPHER INVENTS ALICE IN WONDERLAND
Lewis Carroll

Charles Lutwidge Dodgson, born in 1832 in a small town in Cheshire County, England, lived his entire life under the long reign of Queen Victoria. In his time England was justly proud of its democratic institutions, its steady advance in technology, and its expanding empire. Like all other great powers, it considered itself the trustee of a great mission of civilization, which it would achieve in the name of other nations. As a student at Oxford, Dodgson believed that this overly optimistic image would inevitably reveal its contradictions and ambiguities: the rights and values that British society considered precious, the British government denied and suppressed in the rest of the Empire, from Ireland to India. Industrialization opened an ever-widening gap between the interests of the countryside and of the city, where industrialized factories were beginning to make life unbearable. A rigid moral code guaranteed order and efficiency to society as a whole, but severely limited the free expression of the individual.

About 1865 Dodgson—lecturer of Mathematics at Oxford, an ordained deacon of the Anglican Church, and author of various scientific works—met an enchanting three-year-old girl, Alice Liddell. From that moment on, Reverend Dodgson not only continued his official university and ecclesiastical activities, but spent countless hours making photographs of Alice and her friends. To amuse them he invented strange, enchanting tales steeped in a world of dream and fantasy that he published under the pseudonym Lewis Carroll. Charmed by their childish games and costumes, which created a miniature adult world where no limits were imposed on imagination, Carroll was likewise attracted by the fantastic transformation of reality that photography allows. Photography stops time forever, bringing the faraway, unreachable world near and visible, shrinking and enlarging it at will.

The writer Lewis Carroll became famous among children all over the world for his tale *Alice's Adventures in Wonderland* (1865), in which he tells of the ups and downs of a little girl who shrinks when she drinks a potion marked "Drink Me" and grows when she eats things

marked "Eat Me." Her adventures continued in *Through the Looking Glass* (1872). Carroll's photographs demonstrate the key features of this imaginative world: the marvelous memory of childhood and happy summer days, the dreamy images, the make-believe disguises.

Lewis Carroll, *Xie Kitchen as a Chinese*

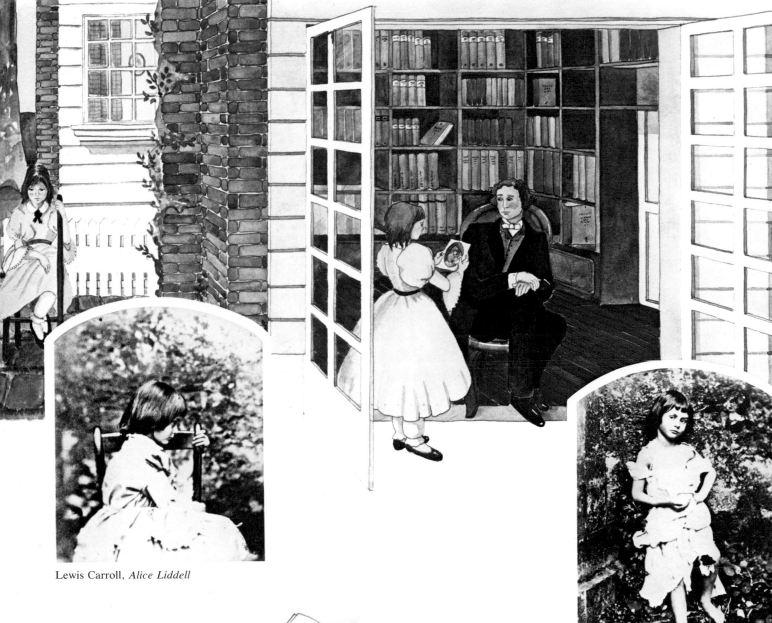

Lewis Carroll, *Alice Liddell*

Lewis Carroll, *Alice Liddell*

29
PAINTING VERSUS PHOTOGRAPHY
Peter Henry Emerson

Claude Monet, *Terrace at Saint-Adresse*, 1866

Peter Henry Emerson was one of the key figures in a cultural controversy at the end of the nineteenth century that led photography to define itself as a distinct art form, separate from painting.

Born in Cuba in 1856 of an American father and British mother, he spent his youth in the Caribbean and the United States. When his father died, Emerson moved to Great Britain, where he completed his university studies in medicine; his special interest in biology prompted him to observe nature in all its forms.

While traveling in Italy, where he was able to view the highlights of art history, he became convinced that the only true art is the one that imitates nature. In 1882 he acquired his first camera and began to photograph the charming landscape of Suffolk, along the east coast of England.

Following the example of the French painters of the day who were called, with some disdain, "Impressionists" (because they preferred to paint outdoors and render the "impression" of what they saw rather than the minute details), Emerson made his photographs only out of doors, using a simple, straightforward style to capture the lives of local fishermen and farmers.

Just as the Impressionists broke with tradi-tional painting so, too, Emerson chose a photographic style contrary to the style then in vogue in England, where the best-known practitioners were Julia Margaret Cameron, Oscar G. Rejlander, and Henry P. Robinson. These photographers staged lavish scenes, usually posing their models in costumes to depict a story or a moment from literature or history. Using a method called combination printing, they photographed several separate subjects and sandwiched the negatives together to make a composite picture.

In a book published in 1889 entitled *Naturalistic Photography,* Emerson proposed that a photographed image ought to have the same qualities as the image seen by the naked eye. He attacked both documentary photography, as being sharper in focus than natural vision, and the photography of Rejlander and Robinson, which tampered with the scene that occurred in nature.

Despite his limitations as an artist and contradictions in some of his theories, Emerson had a positive influence on the subsequent development of photography: as judge of an important London competition, he awarded first prize to an image submitted by a young American living in Berlin named Alfred Stieglitz, who would bring a new dimension to the art of photography.

Oscar Rejlander, *Head of Saint John the Baptist,* about 1860

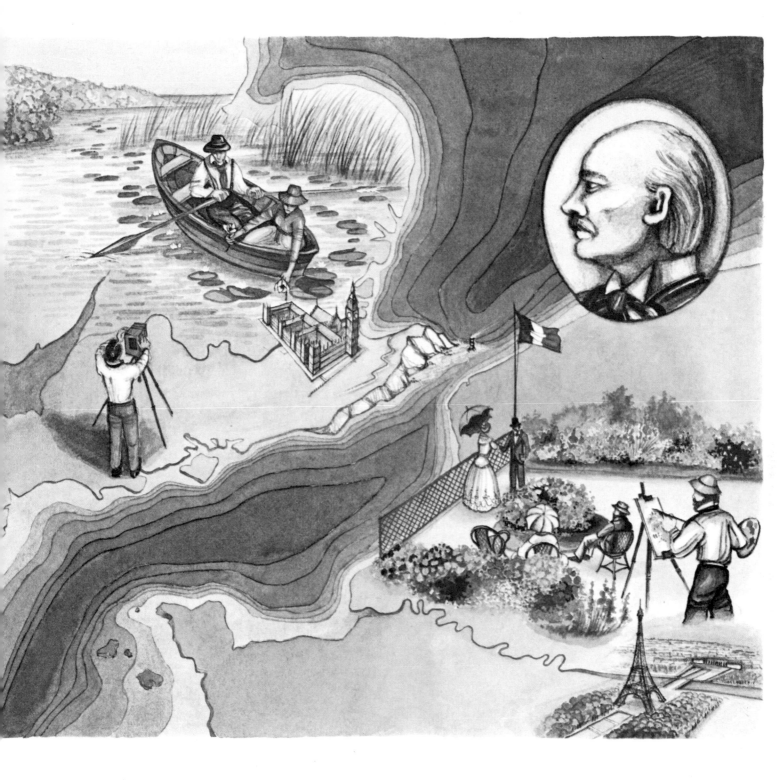

Peter Henry Emerson, *Gathering Waterlilies*, 1880s

Peter Henry Emerson, *A Stiff Pull, Suffolk*, 1880s

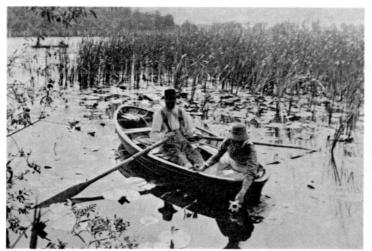

PICTURES FOR EVERYONE BY EVERYONE

Like most of Eadweard Muybridge's motion series, Emerson's naturalistic photographs of the English countryside were made with the new gelatin dry-plate method, which began replacing the wet collodion technique almost the instant it was discovered.

Proposed in 1871 by the English physician Richard Leach Maddox, the gelatin-coated plate marked a major advance toward the subsequent popularization of photography. Unlike collodion, which had to be kept wet during the developing stage, the gelatin emulsion could be allowed to dry before use and the exposed plate developed later. As a result the camera could go anywhere, and photographers were quick to explore the possibilities of this new freedom.

Small cameras were developed and equipped with shutters, a mechanical device that replaced the manually operated lens cap. Some cameras even had extra plates, which allowed photographers to take one picture after another in sequence. But gelatin dry plates were still made from glass, a fragile, cumbersome material, so researchers and scientists continued to experiment with lighter and more practical materials for negatives. Hannibal Goodwin solved this problem in 1887 with the use of celluloid, a substance flexible enough to be wound up into a roll—the forerunner of modern-day film. Taking advantage of this discovery, George Eastman of Rochester, New York, patented in 1888 a small, box-shaped camera called the *Kodak,* already loaded with a roll of film. The Kodak produced 100 circular images, each 2½ inches in diameter, and it was remarkably easy to use. Now, by following just three simple steps, almost anyone could make a picture: 1) pull the cord to set the shutter spring; 2) turn the key to advance the film; and 3) press the release button.

Once the entire roll had been exposed, the photographer took the camera to the nearest Kodak center. There, technicians emptied the camera, developed and printed the exposed roll, and returned the camera to the customer reloaded with a new roll of film. Kodak's slogan "You press the button, we do the rest" became world famous, and the camera soon became a popular instrument of communication.

In 1900, thanks to the talent of project designer Frank Brownell, the Eastman Kodak Company brought out an even smaller camera, this time for children—the Brownie. In its first year alone, the Brownie sold more than 100,000 models. Brownies were manufactured until 1954, and millions of people used them to preserve the highlights of their own lives.

Kodak advertisement
in *Life* magazine, 1911

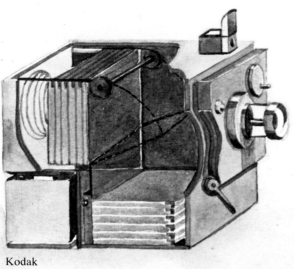

Kodak

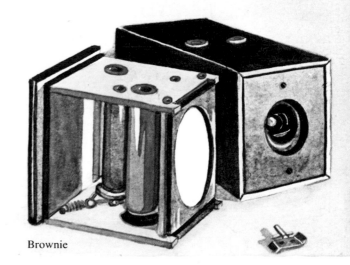

Brownie

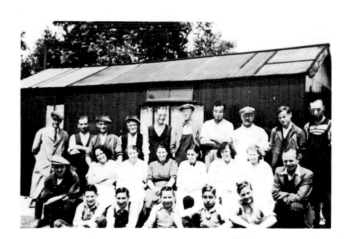

Early snapshots by anonymous photographers

Twentieth-century Visions

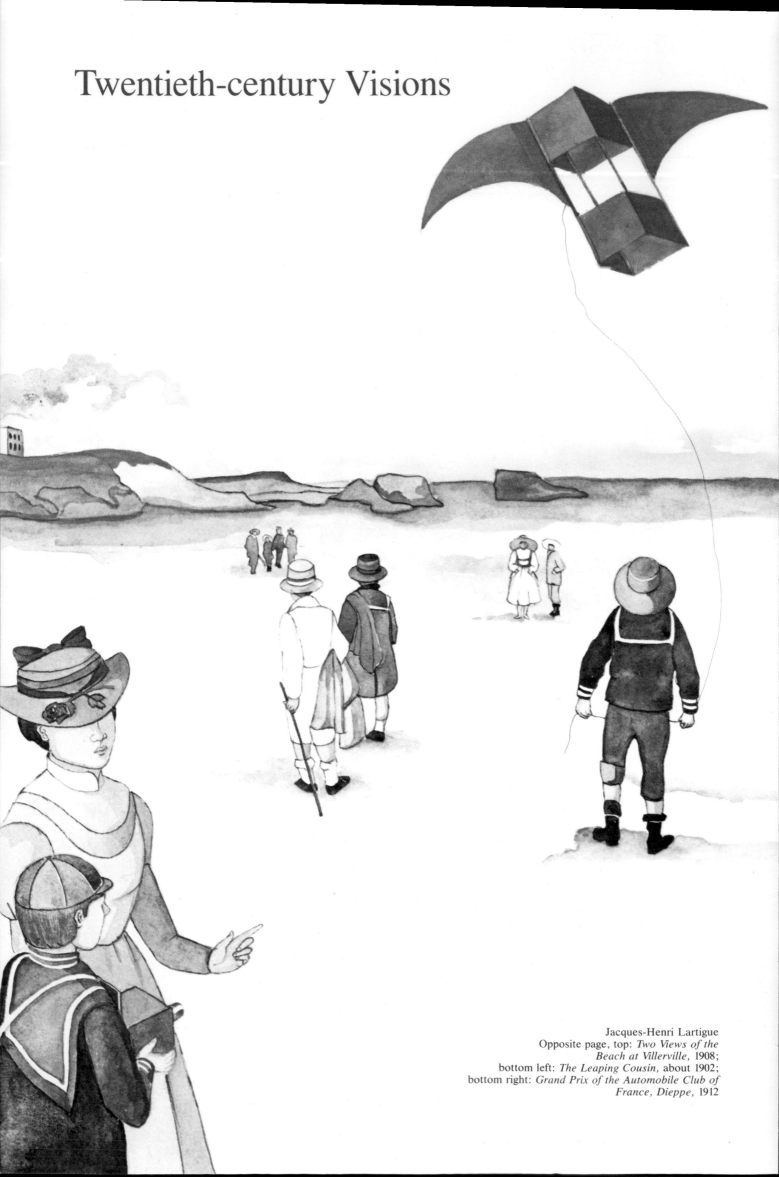

Jacques-Henri Lartigue
Opposite page, top: *Two Views of the Beach at Villerville*, 1908;
bottom left: *The Leaping Cousin*, about 1902;
bottom right: *Grand Prix of the Automobile Club of France, Dieppe*, 1912

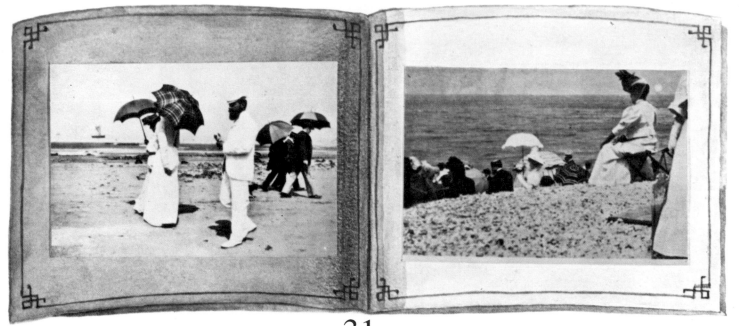

31
A CHILD'S DIARY
Jacques-Henri Lartigue

After its major defeat by Prussia in 1870 and the subsequent fall of the Emperor Napoleon III, France under the Third Republic gradually regained its former eminence during the forty-four years of peace that followed. This era of peace, along with the acquisition of colonies in Africa and Indochina, contributed to a new era of prosperity in France.

The Universal Expositions (for which the futuristic Eiffel Tower was built in 1889), the appearance of the first automobiles, the awkward attempts at flight in airplanes equipped with the strangest wings imaginable, the birth of the cinema, the influx of great native and foreign artists, and the exciting theater and night life all helped make Paris the Ville Lumière—the City of Light—the cosmopolitan capital of a golden world that entered the new century with great hopes and dreams but with few certainties.

Born in 1894, Jacques-Henri Lartigue grew up in this exciting atmosphere. The beloved son of a family of the middle class, the most important

social class in that age, Jacques-Henri experienced the bliss of an innocent, untroubled childhood. When he was seven, his father gave him his first camera.

Young Lartigue's curious, roving eye began to look all around, eagerly taking in everything it saw. "I was happy and soothed," he confided to his diary, "because I felt that I had captured and treasured in my head the essential pictures of the best moments of my day." From that time early in the century he began to photograph his world with the freshness of a child's vision. A fond hug for *maman* and *papa*, his cousin leaping downstairs, the Grand Prix race, the beaches his family frequented, and hundreds of other intimate moments were collected and preserved year after year in the pages of his photograph album. In 1963 The Museum of Modern Art in New York presented these images to the public, and they have since become a collective visual diary of our century's happy, distant childhood.

32

THE FIRST MODERN PHOTOGRAPHER

Eugène Atget

Eugène Atget, *Park, Paris,* about 1910

As the nineteenth century came to a close and the twentieth century began, the rhythm of life in Western countries accelerated harshly and abruptly. With the train, automobile, airplane, telephone, electricity, and the gadgets of science, man worked, traveled, and experienced his world faster and faster. The cities expanded, changed, and began to lose their identities.

In Paris, new factories and modern buildings made of iron and cement rose alongside centuries-old farmsteads, houses, and churches. Away from the great traffic-congested boulevards, in scattered small lanes and narrow streets, life was still regulated by the slower rhythm of the past. In this quickly changing Paris, the solitary figure of Eugène Atget roamed up and down the ancient neighborhoods with his cumbersome old-fashioned camera. With long exposures and carefully studied com-

positions, he tried to capture the beautiful corners of the city, not yet forgotten but soon to be replaced by concrete and steel.

Atget began taking pictures in 1897, when he was already forty years old, after having been an actor and painter. Although he sold his photographs, Atget went beyond the sure-fire formulas of other commercial photographers. Unlike sidewalk photographers and postcard vendors, he did not limit his photographic survey to important buildings and avenues; he in-

Eugéne Atget, *Restaurant in rue des Blancs-Manteaux, Paris,* about 1910

cluded the most humble and ordinary street corners. His many thousands of pictures document the street plan of the Paris of his time, but they are far more than mere archival records. Some of his most beautiful photographs are of gardens and parks, where nature's splendor and harmony complement the forms of man's sculptures, fountains, and buildings. Others of his photographs—an abandoned courtyard or a shop window where reflections of houses and trees mix haphazardly with signs and mannequins—provoke a sharp cry of nostalgia from memory's murky depths. These images disclose an endless succession of meaningful details that can be grasped only through deep, thoughtful observation. Because of their intuitive grasp of the meditative beauty of a simple scene, they often served as models for painters such as Maurice Utrillo and Georges Braque.

Atget's importance was recognized only after his death in 1927. When his images became known in the United States through the efforts of the photographers Berenice Abbott and Man Ray, they influenced many other photographers, who would adopt his extraordinary way of observing and photographing the world around us.

Top: Alfred Stieglitz in his art and photography gallery "291" remembers receiving first prize in the competition judged by P. H. Emerson

Left: Alfred Stieglitz, *The Steerage*, 1907

THE CHAMPION FOR PHOTOGRAPHY AS A FINE ART
Alfred Stieglitz

When photography first appeared, it revolutionized the way people created and thought about images. For David O. Hill, Robert Adamson, Félix Nadar, and Lewis Carroll photography created new ways of understanding human nature through portraits; for Roger Fenton, James Robertson, Felix Beato, and Mathew Brady it offered new means of representing and communicating historic events; for Maxime Du Camp, Francis Frith, Timothy H. O'Sullivan, William Henry Jackson, and Carleton Watkins it expanded the vision of the world and nature; for Eadweard Muybridge it made possible the realization and study of formerly imperceptible phenomena. Despite all this, by the turn of the century photography had still not been widely recognized as a means of artistic expression.

Alfred Stieglitz was a key figure in the evolution of the art of photography, and his work was decisive in winning greater cultural recognition for his medium. Born in 1864 of a wealthy German immigrant family in Hoboken, New Jersey, Stieglitz spent his adolescence in New York. In 1882 he enrolled in the Berlin Polytechnic School in Germany, his parents' homeland, to study for a career in engineering. The courses in physics and mechanics did not interest him as much as his course in photography with Professor Heinrich Wilhelm Vogel, however, and the following year Stieglitz devoted himself exclusively to photography. After some initial disappointments, the quality of his work was recognized, and he received the first prize in the 1887 London competition judged by P. H. Emerson, who regarded the prize photograph as "the only spontaneous one" among those entered.

Stieglitz returned to New York in 1890 and continued to create pictures with the same simplicity and spontaneity, making photographs of the city in all seasons and at every time of day. At the same time he carried on the battle for artistic recognition of photography with a zeal that surpassed even Emerson's conviction and energy. In 1902 he gathered around him a group called "Photo-Secession" and published with the help of Edward Steichen (later the director of The Museum of Modern Art's photography department) the lavish quarterly Camera Work, where for the first time photography was presented as the equal of other art forms.

To compensate for the lack of galleries where photographic exhibits could be regularly held, Stieglitz opened the Little Galleries of the Photo-Secession at 291 Fifth Avenue. Here, again with Steichen's help and support, the first American exhibits of the great European painters and sculptors from Henri Matisse and Pablo Picasso to Constantin Brancusi appeared along with photography exhibits.

Stieglitz's involvement with "291," as the gallery came to be called, and Camera Work ended in 1917, but he continued his many diverse activities until his death in 1946.

Apart from The Steerage—generally considered his masterpiece—Stieglitz photographed his second wife, Georgia O'Keeffe, the skyscrapers of New York and the clouds above Lake George, New York, where he spent the summers. In all his photographs he tried to choose subjects that were external counterparts—"equivalents," as he called them—of his innermost feelings.

Stieglitz's works are in collections at the Museum of Fine Arts, Boston, The Museum of Modern Art, New York, and the National Gallery, Washington, D.C.—well-deserved recognition for a master who strove to establish photography as an art in its own right.

34
CRUSADERS WITH CAMERAS
Jacob Riis and Lewis Hine

Jacob Riis, *Mullen's Alley, Cherry Hill, New York,* about 1888

The United States, the first democratic republic of the modern era, began as a nation of immense territory and almost unlimited resources. From its birth it represented the goal and dream of all nations seeking liberty and well-being. Millions of people of every race and language came to the New World to seek their fortunes, bringing with them only their own determination to start anew and their hopes for a brighter future. After the Irish immigration of the mid-nineteenth century, an even greater influx of newcomers arrived from all over Europe. New York, the natural entry point for this unending wave of people, became the home of thousands of Italians, Germans, Jews, Slavs, Russians, and Armenians. Often uneducated, with different political and cultural traditions, the immigrants created a series of grave social problems that no public administration had ever before confronted. These new Americans had to endure crowded living and working conditions, poor sanitation, and hunger, and those to feel the effects most keenly were the orphaned and abandoned children growing up on city streets.

Jacob Riis landed in America from Denmark in 1870. After overcoming the hardships experienced by every poor immigrant, he found a job as a journalist for the New York *Tribune,* then later for the *Sun.* As a police reporter, he spent years frequenting the city's most wretched and dangerous areas. Moved by the immigrants' plight, he began to seek social reforms. In order to support his investigations of overcrowded tenements, he took hundreds of photographs in the rundown neighborhood around Mulberry Street on the Lower East Side of Manhattan.

In 1890, after three years of working for new laws, Riis published his book *How the Other Half Lives,* which revealed the unbearable conditions of the slums. His impassioned denunciation, accompanied by raw, sometimes brutal images, shook public opinion out of its indifference, and as a result the city took measures toward social change.

Sociologist Lewis Hine carried on Riis's courageous social commitment. In 1907, at the age of thirty-three, Hine began to use his free time away from his teaching duties to photograph the Europeans landing on Ellis Island, the official immigration station in New York harbor. Hine was gifted with a mature, profound vision, and, unlike Riis, he portrayed the positive as well as the negative aspects of immigrant life. Besides the misery, shabbiness, and brutalization of the poor, he showed their basic human dignity. In later years, Hine received a government commission to survey the tragic conditions of children working in factories, and his moving images stimulated passage of new labor laws to prevent child exploitation.

Lewis Hine, *Child Worker in Textile Factory,* about 1910

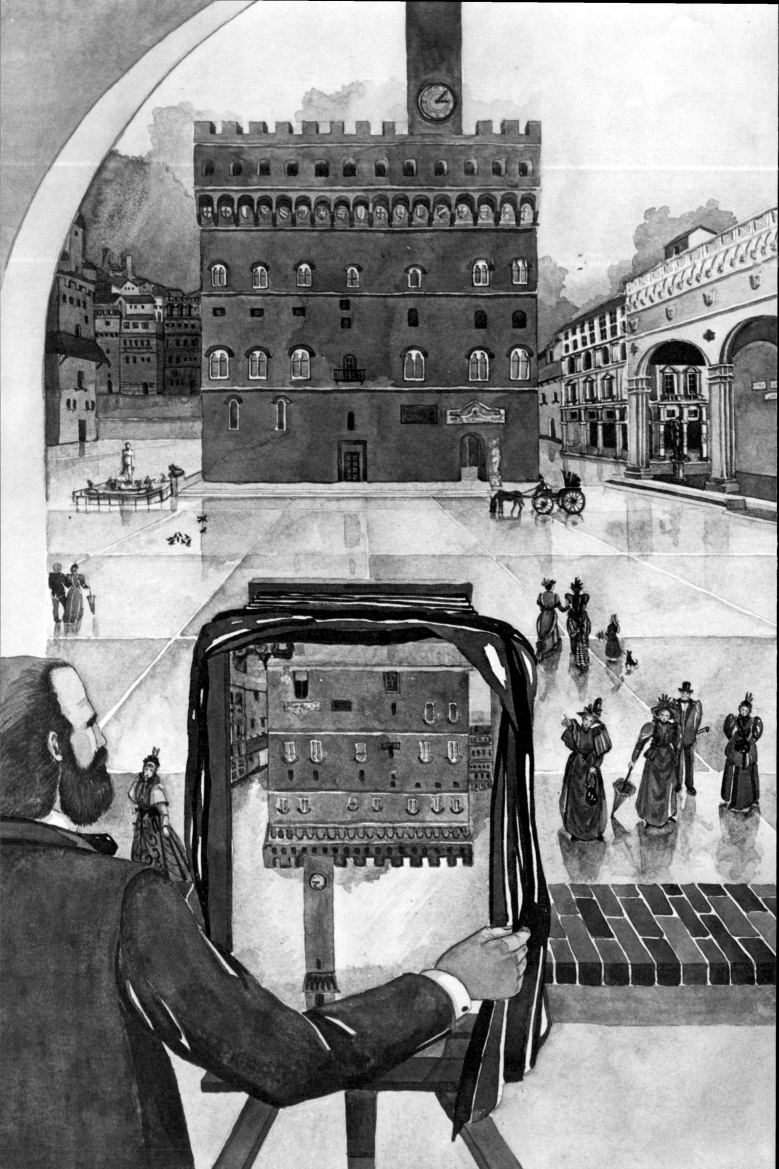

35
A CULTURAL PANORAMA
The Alinari Family

Italy's rich cultural tradition and achievements in the visual arts began to decline during the first half of the nineteenth century. Literature and opera largely replaced the visual arts in Italy, which was still divided into many small states, some occupied by the Austro-Hungarian Empire. Photography, too, was practically absent from Italian history and culture during these decades.

In 1861, when patriot Giuseppe Garibaldi succeeded in uniting Italy under King Victor Emmanuel II, a new era in Italian arts began. Rome was still the seat of the Vatican State, and Florence became the capital of the new kingdom. It was in Florence that the great revival of photographic activity took place, initiated by Leopoldo, Giuseppe, and Romualdo Alinari.

Their studio, founded in the 1850s, specialized in the reproduction of artworks. Popular throughout Italy, where the roots of recent unity were being sought in cultural achievements of the past, these prints also sold in great quantities to art lovers all over the world. In 1880, Leopoldo's son, Vittorio Alinari, took over the directorship of the studio.

Young Vittorio, who had grown up in the stimulating environment of Florence, decided to broaden the Alinari archives: he began systematically to photograph the monuments, works of art, and important landscapes in Italian territory.

Working under Vittorio's alert guidance, dozens of photographers began to document the significant urban and architectural works, the predominant economic activities, and the characteristic customs and practices of every Italian city and region. These photographs portrayed the Italy of the late nineteenth century, a nation still young but rich with ancient civilization, deficient in natural resources but marching toward industrial expansion, with a southern region plagued by human and social problems but with illustrious civic traditions and important commercial centers. During World War I, Vittorio Alinari continued to celebrate his country's culture by photographing the Italian landscapes described by Dante in the *Divine Comedy*. Alinari's images were never meant to be works of art, but they nevertheless constituted a grand project of faithful photographic documentation, which yielded an invaluable cultural record.

Alinari Family, *View of Saint Peter's across the Tiber,* Rome

Alinari Family, *The Duomo from the Palazzo Vecchio,* Florence

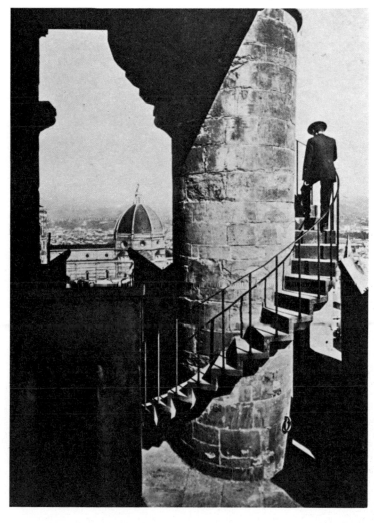

36
HONORING HUMANITY
Paul Strand

Paul Strand was born in 1890 in New York, to a family of Bohemian origin. Enrolled at the Ethical Culture School, he learned the fundamentals of photographic technique in a course given after school by Lewis A. Hine, a science teacher who had just begun to explore social photography. One day Hine took his class to visit Alfred Stieglitz's "291" Gallery. It was an important moment in Strand's life. Confronted with works by the best-known contemporary photographers, Strand knew photography was what he wanted to do.

After he graduated from high school, Strand no longer had a darkroom where he could develop and print, so he joined the New York Camera Club. Disappointed by the amateurism he found there, he left the club after two years and began to spend his free time at Stieglitz's gallery. His encounters there with painters, sculptors, and photographers gave him an opportunity to examine the different approaches of each kind of artist; his appreciation of the other arts helped him to grasp the essential originality and special characteristics of photography.

This time of Strand's career was not only a period of theoretical discovery, but also a time of intense activity. On Wall Street and Fifth Avenue, Strand photographed with perceptive freshness the anonymous crowds and the destitute beggars, producing pictures incomparable for their expressive power and profound intuition. They so impressed Stieglitz that he exhibited them at "291" in March 1916 and published a selection in the last two issues of *Camera Work*. These photographs marked a turning point in the still early history of photography as an art: they used the everyday world to reveal something of the photographer's inner self.

In the early 1920s Strand acquired a movie camera and began to earn his living as a camera man for scientific films and newsreel documentaries. In his spare time he photographed machinery and other examples of industrial civilization, but he increasingly detached himself from the values behind modern progress. Gradually, he began to seek American places still untouched by industrialization, trying to elicit the mysterious connection that binds the nature of a place—its rocks, sky, trees—to the face of the person who was born and lives there.

After a stay in Mexico, he devoted himself entirely to movie making, as a director and as the president of the production company Frontier Films. He took up still photography again only in 1944, in New England. Collaborating with writer Nancy Newhall, Strand traveled throughout the region to produce the book *Time in New England* in 1950.

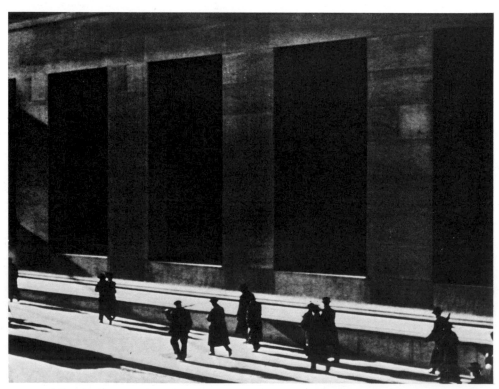

Paul Strand, *Wall Street, New York,* 1915

In 1951 Strand moved to Europe and began to visit different parts of the world, probing in depth the particular character of each place he saw. In his book *Un Paese* (*A Village*), published in 1955, Strand produced a remarkable portrait of Luzzara, a small town in the province of Reggio Emilia and birthplace of the writer Cesare Zavattini. Strand photographed every aspect of life in Luzzara—the landscape, the town, and the people—and Zavattini contributed a moving commentary.

After undertaking similar projects from Egypt to Ghana, from France to the Hebrides, Strand returned to his home in Orgeval, France, where he focused his attention on his garden. His detailed photographs of leaves and plants are among the most beautiful he took in his life. "The artist's world," he wrote, "is limitless. It can be found anywhere, far from where he lives or a few feet away. It is on his doorstep." Strand died in Orgeval in 1976.

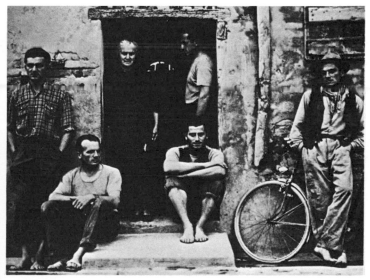

Paul Strand, *The Family, Luzzara, Italy,* 1953

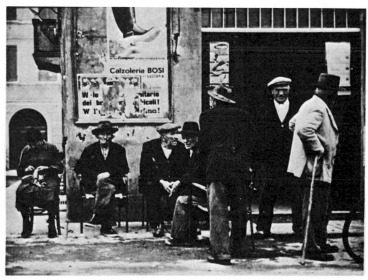

Paul Strand, *Tavern, Luzzara, Italy,* 1953

37
PHOTOGRAPHY AS TRANSFORMATION
Edward Weston

"I got my first camera when I was sixteen. . . . My whole life changed—because I became interested in something definite concrete." In 1902, after working in several professional photography studios, Edward Weston moved to California from Illinois. In 1911 he opened a studio where he produced portraits in the soft-focus style called Pictorialism. Though already old-fashioned, this style guaranteed him great success with his customers and in the many photographic competitions he entered. He was more content than ever with Pictorialism when, on a trip east, he photographed the Armco steel mill in Ohio using sharp focus and paying careful attention to light, contrast, and composition, without manipulation or distortion. It was a revelation. The work he did in Ohio represented for Weston a major turn in his way of looking at reality, and the incisive style he—and others— used became known as "straight" photography. His disciplined compositions revealed a hidden

Edward Weston, *Pepper No. 30*, 1930

beauty in the architectural tangle of the factory.

Weston next settled in Mexico City. Ten years after the revolution that had broken out in 1910, Mexico City was an exciting cultural mecca. There the mural painters Diego Rivera, José Clemente Orozco, and David Alfaro Siqueiros lived and worked, and Weston had at his disposal materials much different from those he had used before—bright light and colors, shifting clouds, and an intense dramatic life. In these new surroundings he enthusiastically sought out abstractions in the shapes of clouds and other forms in nature and in the contours of the female body. By studying his subjects thoroughly he hoped to tap the common source, hidden and invisible, that gives form and structure to all things.

The Mexican period affected all of Weston's subsequent photography. When he returned to California he concentrated less on "general vistas" and more on the forms of tree trunks, leaves, fruit, and shells. And he tried to represent these objects not as they appeared to the eye of any observer but rather as they were shaped by his own intuition, through understanding of their structure and their apparently insignificant details. As Weston said, he identified with anything in which he recognized a part of himself. He photographed natural objects as if they were sculptures, using delicately balanced tones of black, white, and gray to reveal their unchanging, almost perfect forms.

Weston rendered the presence of industrial civilization in terms of what had been abandoned, not what was thriving. Thus, he recorded the ghost towns of the Far West, the remains of cars, and an enormous coffee-cup sign in the desert.

Weston illustrated with his powerful images a special edition of Walt Whitman's book of poems *Leaves of Grass,* and in 1946 he was featured in a major exhibit organized by the newly opened department of photography in The Museum of Modern Art in New York.

In his last photographs, taken near his home in California and on the nearby beaches at Point Lobos, the signs of decay are ever more present. Weston considered death a part of life and saw it represented in skeletal, parched trees and in the bodies of seagulls and pelicans floating on the sea's low tides.

Edward Weston, *Mojave Desert,* 1937

38
PORTRAIT OF THE DEPRESSION
The Farm Security Administration

American photographers have always had an important role in interpreting their country's history. Mathew B. Brady and his team portrayed distinguished Americans and the tragic years of the Civil War; Timothy H. O'Sullivan and William Henry Jackson followed the discovery of the Far West; Alfred A. Hart and Andrew J. Russell documented the construction of the transcontinental railroad; Jacob Riis exposed the hard circumstances of the destitute; Lewis Hine portrayed the wretched conditions of child labor. In 1929, little more than ten years after the United States' victory in World War I had established it as a major power, the nation underwent a grave industrial and agricultural crisis. A new generation of photographers was on hand to document this historic period.

When the war ended in 1918, the United States lacked a long-range political program for converting a wartime economy into a peacetime economy. The swift and costly modernization of industry, mining, and agriculture resulted in the overproduction of goods that the international market could no longer absorb. With too many products to be sold, prices declined, and when a series of interlinked business failures culminated in the collapse of trade on the Wall Street Stock Exchange on "Black Monday," October 24, 1929, the weakened economy collapsed. It was the beginning of the Great Depression.

Shock waves swept through America. No longer able to bring their surplus harvests to market, farmers failed to pay off debts owed on their new machinery. As if this were not enough,

a terrible drought struck the Midwestern Corn Belt, beginning in 1932. Forced to sell their land, thousands of farmers and their families abandoned their homes and joined the ever-increasing hordes of migrant workers and unemployed. They gathered their belongings in old automobiles and makeshift wagons and began to journey in search of work and a place to live.

Democratic candidate Franklin Delano Roosevelt won the presidential election of November 1932 with promises of sweeping reforms in a wide-ranging political program to be called the New Deal. In order to administer the funds immediately allocated by a new law favoring farmers, the president established a government agency called first the Resettlement Administration, and after 1937 the Farm Security Administration (FSA), directed by the noted economist Rexford Guy Tugwell with the assistance of Roy E. Stryker.

Stryker's job as head of the History Section was to gather evidence of the plight of farmers and the accomplishments of the assistance programs that aided them. He knew that the photographs of the farmers' situation that had been taken so far failed to communicate the impact of the national drama then unfolding. So, beginning in 1935, Stryker first hired photographer Arthur Rothstein and then decided to expand his staff. Soon he had sent across America John Collier, Jr., Jack Delano, Walker Evans, Theodor Jung, Dorothea Lange, Russell Lee, Carl Mydans, Ben Shahn, Arthur Siegel, John Vachon, and Marion Post Wolcott. Stryker gave them locations to cover and detailed shooting scripts, but the remarkable images they brought back resulted from their own judgment and expertise. Instead of merely photographing poor farmers, the photographers captured the relationship between rural poverty and improper land use, the effect of the economic situation on small communities, and the decline of the cities during the Depression.

From 1935 to 1942 his team of photographers produced tens of thousands of photographs—a complete visual survey of the United States. Once again the photographer held up a mirror to give society a true, if disturbing, picture of itself.

THE FSA AND THE COMMON MAN
Arthur Rothstein, Dorothea Lange, and Ben Shahn

In July 1935 a university student and pupil of Stryker with only a vague interest in photography, the twenty-one-year-old Arthur Rothstein was the first photographer to be hired by the Resettlement Administration's History Section.

Rothstein began his documentary work in Oklahoma, where the drought had turned once fertile plains into the Dust Bowl. While making a series of images on a farm, he photographed a farmer and his two children caught in a whirlwind of sand as they tried to reach their barn. Circulated in every newspaper, *Farmer and Sons Walking in a Dust Storm* became a symbol for the devastation and abandonment of lands in the Midwest. Rothstein accomplished the widest-ranging, most uninterrupted survey for the FSA, which he left in 1940 for a successful career as a photojournalist.

Dorothea Lange was another important figure among these photographers. Born in Hoboken, New Jersey, in 1895, she left home at the age of eighteen and settled in San Francisco, where she opened a portrait studio in 1919. Her talents

for dealing with people and setting up carefully arranged compositions soon made her one of the most popular portrait photographers in the city.

In 1932 Lange departed from her usual kind of picture, when she took her camera into the street to photograph *White Angel Bread Line,* a picture of hungry men waiting for the food given out daily by a wealthy San Francisco woman called the "White Angel." Lange became more and more interested in social problems, and in a report carried out with the economist Paul Taylor—later her husband—Lange anticipated Stryker's own method of investigation. When Stryker learned of her work, he offered her a job.

In March 1936, in a migrant camp in California's Nipomo Valley, Lange captured the troubled face of a migrant mother. *Migrant Mother,* together with Rothstein's *Farmer and Sons,* came to represent the tragedy suffered by the drought-stricken farmers. "I saw and approached the hungry and desperate mother," Lange wrote in her field notes. "She said that

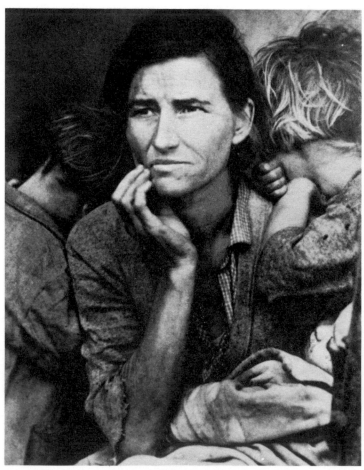

Dorothea Lange, *Migrant Mother, Nipomo, California,* 1936

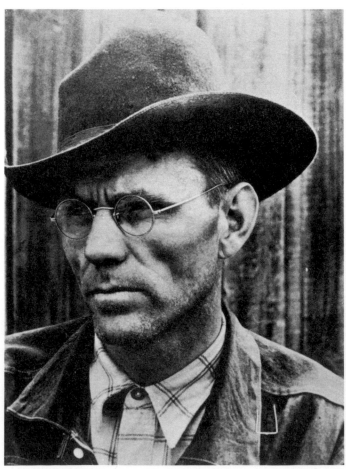

Arthur Rothstein, *Walter Latta, Montana,* 1939

they had been living on frozen vegetables from the surrounding fields and birds that the children killed. She had just sold the tires from her car to buy food."

Lange's years on the road took her from Mississippi to California, from Oregon to Arkansas. Her powerful images of the homeless migrants riding old-fashioned Model T Fords inspired the cinematography of John Ford's film *Grapes of Wrath,* based on a novel by John Steinbeck.

After she left the FSA in 1940, recurring bouts of illness diminished Lange's legendary energy, and she made photographs only intermittently, using her expert eye to produce memorable images of people, on travels with her husband in Africa and Asia in the 1940s and 1950s.

Ben Shahn, a painter born in Lithuania and a friend of Walker Evans (with whom he shared a studio in Greenwich Village), began taking photographs as an aid in sketching for his murals. In his work for Stryker, Shahn used a small camera to make spontaneous pictures on the street, unobserved by his subjects.

Although they did not achieve the same notoriety as Rothstein, Lange, and Shahn, the other members of the FSA group were also profoundly alert to mankind's suffering along the roads of America, and their photographs helped a nation remember its less fortunate citizens.

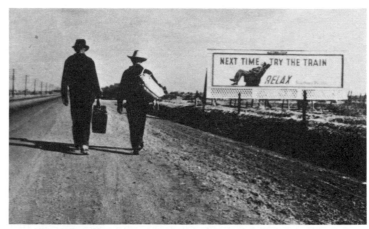

Dorothea Lange, *Towards Los Angeles, California, 1937*

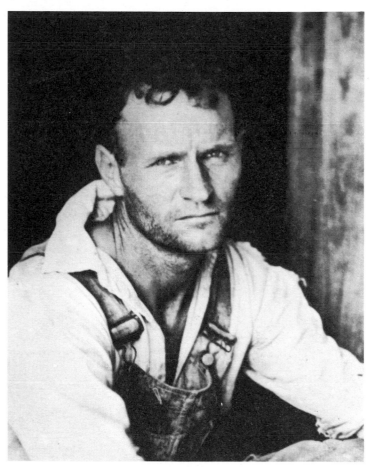

Walker Evans, *Floyd Burroughs, Cotton Sharecropper, Hale County, Alabama,* 1936

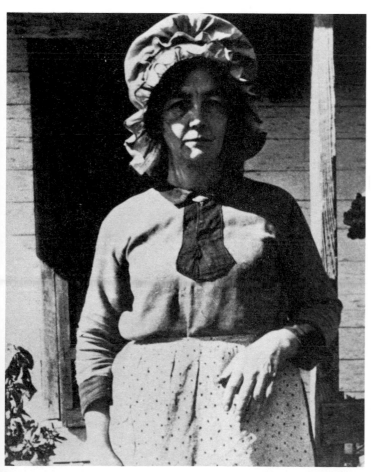

Arthur Rothstein, *Mrs. Nicholson, Virginia,* 1935

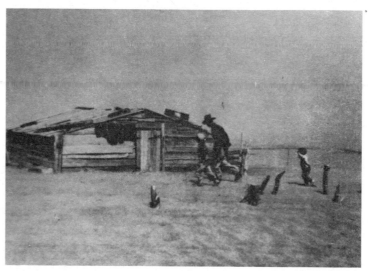

Arthur Rothstein, *Farmer and Sons Walking in Dust Storm, Oklahoma,* 1936

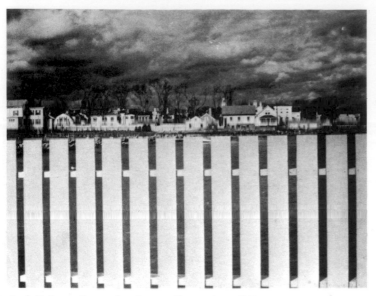

Jack Delano, *Fence, Stonington, Connecticut*, 1940

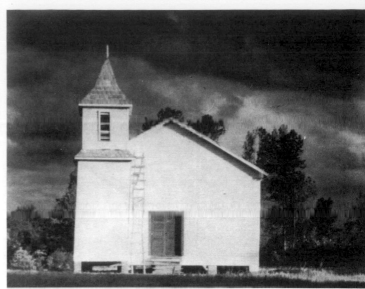

Walker Evans, *Church*, 1936

40
THE NEW DOCUMENTARY TRADITION
Walker Evans

The years of the Great Depression also saw a profound change in the urban landscape and in the consciousness of people who inhabited it, a change documented by the powerful vision of Walker Evans. Evans began taking photographs in 1928, at the age of twenty-four, after a brief stay in Paris, where he attended the Sorbonne and came into contact with European civilization.

Returning to New York, Evans began making photographs. Rejecting the style of Alfred Stieglitz and Stieglitz's friends as too consciously "arty," he began to seek a more straightforward, less self-conscious personal style. He came fully into his own in the artistic environ-

Walker Evans, *Church Interior, Alabama*, 1936

ment of Greenwich Village, where he met and worked with the painter Ben Shahn, the poet Hart Crane, and the writer James Agee.

In his search for authentic, deep, and lasting images, Evans—alone among FSA photographers—preferred an old-fashioned 8 x 10-inch view camera for his work in the 1930s in order to eliminate extraneous details from his carefully selected views.

Evans's choice of the view camera was justified by his attempt to return to a classical concept of art and life. In fact, when sent by Stryker to the Deep South, from Virginia to Louisiana, Evans concentrated on the neoclassical architecture of the old cotton plantations, ruined abandoned monuments of the last great pre-industrial culture in the Western world.

At odds with Stryker, Evans resigned from the FSA after two years and went to work for *Fortune* magazine. His photographs made from the 1940s until his death in 1975 pay tribute to America's side streets, storefronts, and billboards. One critic has called Evans the "world's greatest expert at photographing empty rooms in houses and making them echo with the people who live there." Evans's best-known project features people as well as the buildings they inhabit: his book with writer James Agee, *Let Us Now Praise Famous Men* (1941), the study of a rural community in Alabama. With this book Evans added a new dimension to the story photographs could tell. Thirty-one images, arranged in a group before the text, gave a picture of the

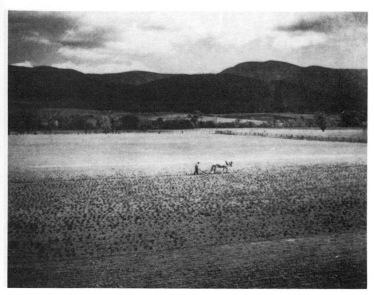

Marion Post Wolcott, *Shenandoah Valley, Virginia,* about 1940

John Vachon, *Advertising, Woodbine, Iowa,* 1940

daily life in a poor Southern family that paralleled the story Agee told in words. This group of photographs makes a powerful statement about our neglect of the poor and their heroic survival in spite of their difficulties. The use of photographs apart from a supporting text would have a great impact on the future of photojournalism.

One of those Evans influenced was Russell Lee. After unsuccessful attempts at painting, Lee was introduced to Stryker's group by his friend Ben Shahn. After Rothstein, it was Lee who contributed the largest number of photographs to the FSA's archives.

John Vachon, hired in 1936 as a lowly office assistant, a year later expressed his wish—immediately granted—to photograph the streets and buildings of Washington, D.C. Since Va-

chon had never held a camera, Evans gave him a few lessons and passed on to Vachon his own direct approach to photography.

Anticipating the themes of American photography and Pop art painting in the 1960s, Vachon concentrated on the most typical aspects and objects of consumer civilization, such as cars and huge billboards, which, with their cold, disquieting presence, animated the new landscape man had made.

Not only did the FSA photographers have a great social impact with their work, they had also developed a new way of looking at America with the camera, observing its anonymous citizens and buildings with directness, and sharing those observations with the world.

Russell Lee, *Organ Deposited by Flood, Mount Vernon, Indiana,* 1937

41
THE MAJESTY OF NATURE
Ansel Adams

Ansel Adams was born in 1902 in San Francisco, the city that gave birth to the great photography of the American landscape in the work of Carleton Watkins and Eadweard Muybridge. While studying to become a pianist, Adams began to make pictures as a hobby during excursions to the Yosemite Valley and the high peaks of the Sierra Nevada. After long deliberation, he decided to devote himself solely to photography. His early work reflects the predominant soft-focus, misty style of the time, though he was already beginning to use the wide range of white, gray, and black tones that would become the hallmark of his mature work. The crucial moment in his maturing process was his meeting with Paul Strand in New Mexico in 1930. Struck by the clarity and sharpness of detail in Strand's negatives, Adams decided to adopt the direct, expressive style known as straight photography.

In 1932, together with Edward Weston, Imogen Cunningham, Willard Van Dyke, and others, Adams founded "Group f.64," named after the smallest aperture permitted by a camera lens—the aperture most often used by the group, whose aim was to make an image as sharp and clear in its details as possible. Later on, Adams enriched his technical expertise by devising the zone system, a special method for measuring the amount of light available in the subject of a photograph. By using the zone system to make a picture, the photographer can achieve a range of tones in the negative, rather than having to make adjustments on the final print.

Ansel Adams, *Burnt Stump and New Grass, Sierra Nevada*

As a mature photographer, Adams depicted places most characteristic of the grand American spirit. Facing the same mountains and rivers and ancient trees as Jackson, Watkins, and Muybridge did, Adams offered a different interpretation. Whereas the nineteenth-century landscapes had the force of territories captured for the first time by the camera, Adams's photographs present a world so richly modulated by light that it almost seems unreal. Man and industry had destroyed nature, and Adams seemed to want to reinvent it with his photographs. He showed nature's beauty in all of its nuances, the countless moods of light and atmospheric phenomena—rain, clouds, snow, and mist. The slanting light at sunset and the recurrent presence of the moon often give Adams's photographs a dreamy, romantic feeling. He sometimes plans weeks or even months in advance in order to capture precisely the light and time of year he wants in a photograph. Sometimes he has camped at a site overnight, assembling his 8 x 10-inch view camera at dusk and sleeping on a special platform constructed on top of his car with his alarm clock set to wake him at dawn. These careful preparations insure that he will be able to select a particular moment from nature's many moods.

Alfred Stieglitz held an exhibition of Adams's work in October 1936 at the gallery An American Place, and Adams's work soon began to appear widely in prestigious books and portfolios. In 1944 he worked with the historian Beaumont Newhall and with David McAlpin to establish the department of photography of The Museum of Modern Art in New York, which has contributed greatly to the recognition of photography as a fine art.

Ansel Adams is one of the best-known photographers in the world today, and his photographs are much sought after by collectors. A large print of *Moonrise, Hernandez, New Mexico,* 1944, was sold in 1981 for the sum of $71,000, more than many photographers make from the sale of their work in their entire lifetimes. Besides his activity as a photographer, Adams has also taught at the California School of Fine Arts, where he has kept alive in numerous generations of new photographers an appreciation for the beauty of nature.

Ansel Adams, *Moonrise, Hernandez, New Mexico,* 1944

Leica camera

Nikon F, modern reflex camera

Polaroid Land camera

Sixty seconds from the
click of the shutter to
the finished print

42
NEW CAMERAS FOR A MODERN AGE

In the years after it was first introduced in the 1890s, film was used primarily in amateur photography. Professional photographers still preferred glass-plate negatives of various sizes.

Introduced on the market in 1924, the Ermanox was equipped with an f.2 lens, which revolutionized photojournalism. The large opening of the f.2 lens allowed "action" photographers to work quickly or to use low levels of light. Advanced as it was, the Ermanox still used plates with single exposures, and, no matter how quickly the exposure was made, replacing the exposed plate still took time—time that the photographer of a fast-paced event could not afford to lose.

The problem of creating a camera that combined professional quality, speed, and portability was finally solved by Oskar Barnack, an engineer at the Leitz optical works in Germany. At the 1925 Leipzig fair, after twelve years of experimentation, he introduced the Leica, one of the most important cameras in the history of photography.

The Leica was the first camera to use 35-millimeter motion picture film, and it was so compact that it could be carried in a pocket. The lenses were accurate and the emulsions quick-setting, so that images made from its thirty-six negatives, each 1 x 1½ inches, remained sharp even when enlarged. News photographers quickly adopted the new camera.

In 1936, the Ihagee company in Dresden introduced the Kine Exakta, which marked yet another technical advance in 35-millimeter cameras. In earlier cameras, the viewfinder had always been set apart from the lens, forcing the photographer to guess at the exact borders of his picture. The Exakta had mounted behind its lens a mirror set at a 45-degree angle, which bounced the image into a tube-shaped viewfinder. Since the photographer now saw the view to be exposed through the lens, he could control with utmost precision his framing and focusing.

As the first "single-reflex" 35-millimeter camera, the Kine Exakta paved the way for countless future models, which became increasingly easy to use; by the 1950s single-reflex cameras were being produced by the millions. Later improvements included the introduction of electronic systems to measure light.

In 1947, the American Edwin H. Land invented the Polaroid Land camera, which delivers a final copy of the picture just one minute after the shutter clicks.

The camera had reached a high level of technical capability that gave photographers even greater flexibility and potential for creative achievement.

Giovanni Chiaramonte, *Carousel, Milan,* 1982

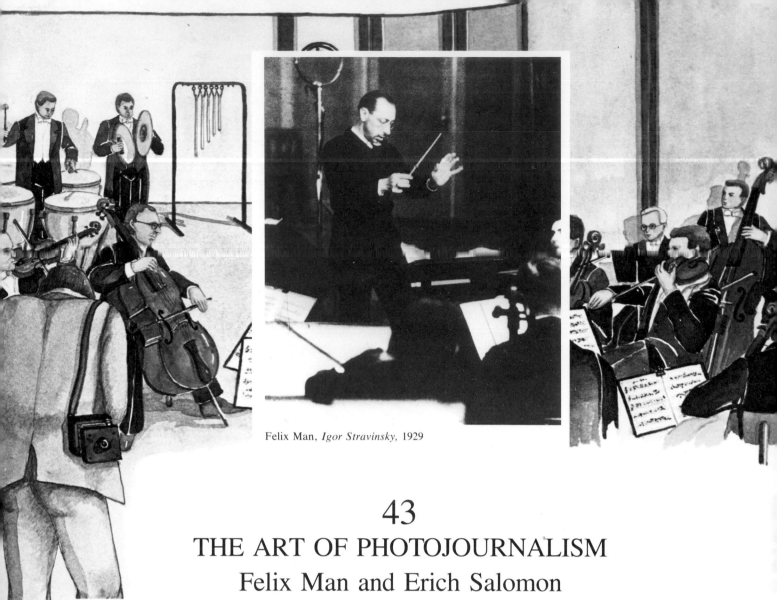

Felix Man, *Igor Stravinsky*, 1929

43
THE ART OF PHOTOJOURNALISM
Felix Man and Erich Salomon

In the 1920s Germany was a contradictory and in many ways fascinating place. While the country's economics and politics underwent a crisis that later culminated in the tragic triumph of Nazism, the German cultural world thrived. Painters like Paul Klee and Wassily Kandinsky renounced an objective, structured view of reality in their work, convinced that they could better express their feelings through the free use of form and color; and many musicians, such as Arnold Schoenberg, set aside the traditional tonal scale in search of a new language of sound. In applied arts, the Bauhaus School of Art and Ar-

chitecture promoted the use of art in industry, thus influencing design and photography.

In those years Germany also made an important contribution to photography. The invention of cameras like the Ermanox, which could use "available light"—the existing light indoors or outdoors—together with the publication of beautifully produced illustrated weekly magazines, brought about a great flowering of photojournalism.

Felix Man was born Hans Felix Baumann in Freiburg in 1893. His family, once prominent in

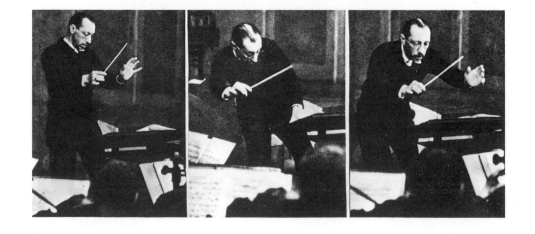

banking, had been reduced to poverty by the economic crisis. At first he studied painting, then went on to earn his living by drawing illustrations based on news reports. When he switched to photography he adopted the pseudonym Felix Man, and, with the help of the Delphot Agency, he worked for the most prestigious Berlin and Munich weekly newspapers and magazines. Interested in portraying the cultural world, as can be seen in his photographs of the Russian composer Igor Stravinsky, Man made series of pictures of the same subject and arranged them in sequence so that the photographs told a story.

Erich Salomon's background resembled Man's —he was a law graduate from Berlin—but as a photographer he directed his attention primarily at the world of international politics. In Geneva, at each session of the newly formed international peacekeeping organization, the League of Nations, as at every other conference of any importance in the 1920s and 1930s, Salomon was always present, ready to use any subterfuge to capture the pompous, self-important poses of powerful men. He created a minor revolution by making candid photographs of dignitaries in casual poses, instead of the usual formal group pictures showing politicians stiffly arranged around the conference table.

When the Nazis rose to power both Man and Salomon chose exile, working for the great weekly magazines based on the German models that had sprung up in other European countries. Man continued to work tirelessly into the 1970s. Salomon, caught by surprise in Holland by the German blitzkrieg in 1940, was detained in the Auschwitz concentration camp in 1943, where he died shortly afterward.

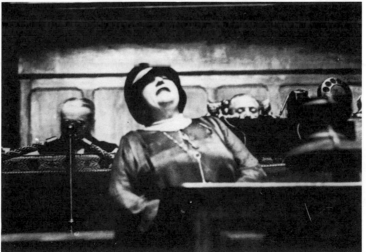

Erich Salomon, *Madame Vacarescu, Rumanian Author and Deputy to the League of Nations,* Geneva, 1928

44

THE GENTLE EYE

André Kertész

André Kertész bought his first camera, a portable ICA, in 1912, just after graduating from the Academy of Commerce in Budapest, where he had been born eighteen years earlier. In his spare time, when he was not working at the Stock Exchange, and in the evenings and on holidays, he strolled around the tree-lined streets and lanes of the ancient city on the Danube, capturing the places and people he knew so well.

Since Hungary had been annexed to Austria under the Hapsburg monarchy, Kertész was sent to serve as an infantryman on the eastern front following the outbreak of World War I. He was able to take pictures only during pauses in battle, pointing his camera at fellow soldiers at

play or at shepherds left alone to tend their flocks on the battlefields devastated by the contending armies.

With the end of World War I, Kertész began to publish his work in several Hungarian magazines, and, in 1925, he decided to move to Paris, where he hoped to advance his career. The images he made in Paris received instant acclaim and appeared in the most important European magazines of the day. The gentle eye that had so deeply explored Budapest now turned upon a turbulent, varied industrial metropolis and

André Kertész, *Pont des Arts, Paris*, 1932

fered Kertész a well-paying contract, and he moved to America. This new environment had a traumatic impact on Kertész, a sensitive artist closely tied to a European way of life. When the contract with Keystone fell through, he took fewer pictures on the street. Instead, in his photographs of New York, human beings crop up strangely on small cement balconies or among threatening mechanical objects and advertising signs; photographed from above, they seem miniature figures against a black asphalt background.

Wherever he has gone in his long life, from Budapest to Paris to New York, Kertész has photographed his own deeply felt response to the individual character of a place.

saw the essential human fabric beneath the urban facade.

Kertész made one picture of an acrobat on the outskirts of town and another of people walking hurriedly and alone on the Pont des Artistes, oblivious to the passage of time ticked off by the hands of a big clock. During the eleven years he stayed in France, his warm, intimate style influenced many of his artist friends: Piet Mondrian, Fernand Léger, Marc Chagall, and Alexander Calder.

In 1936 the Keystone Agency in New York of-

André Kertész, *Fan, New York*, 1937

André Kertész, *Lost Cloud, New York*, 1937

45
PARIS BY NIGHT
Brassaï

A Hungarian like Kertész, Gyula Halász completed his art studies in Budapest and Berlin, then settled in Paris in 1923. Here, under the nickname Brassaï (derived from Brasso, the town in Transylvania where he was born in 1899), he quickly worked his way into the cultural avant-garde, becoming familiar with artists who had already made a name for themselves, such as Pablo Picasso, Salvador Dali, and Alberto Giacometti.

Eclectic by temperament, Brassaï tried his skills at drawing, film making, writing, stage decoration, sculpture, and engraving. He came to photography around the age of thirty. "I led a nocturnal life in Paris," he explained, "sleeping by day and walking by night. During these walks, I saw many marvelous images in the fog and rain. I began to look for a way of expressing what I saw. Around 1930 a woman lent me a camera, and for months I devoted myself to night photography."

Finally able to record the charm of those hours spent wandering the streets of the Latin Quarter and the banks of the Seine, or talking until dawn with friends in Montmartre and Montparnasse, Brassaï photographed the characters who enlivened Parisian nights. Here was a world in which great artists and would-be painters mingled with successful actresses and anonymous dancers of the Folies Bergères; wealthy businessmen dined at Maxim's; and poor lovers scrawled their names on peeling walls—all in search of new sensations and experiences. Brassaï observed: "I had a whole profusion of images to bring to light which, during the long years I lived walking through the night, never ceased to lure me, pursue me, even to haunt me."

An active participant in this human drama, Brassaï sometimes became so much a part of a scene that people went about their lives oblivious to the clicking shutter of his camera—although taking pictures at night was a novel practice at the time. Often, rather than take his subjects by surprise, he preferred to pose them, enlisting their collaboration in his artistic creation and thereby fully reflecting their inner alienation. If a sense of aloneness is the most typical condition of twentieth-century man, then few have succeeded so well as Brassaï in bringing out the true psychological dilemma of modern man.

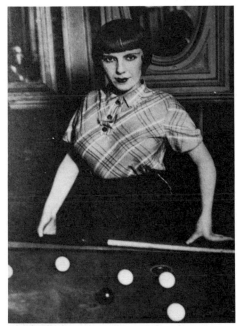

Brassaï, *Prostitute, Paris,* about 1932

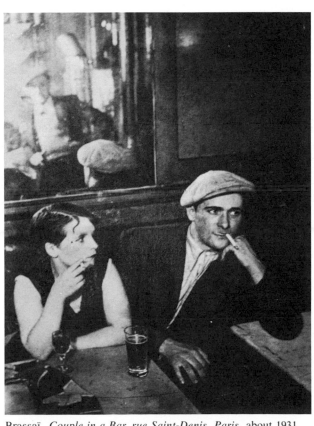

Brassaï, *Couple in a Bar, rue Saint-Denis, Paris,* about 1931

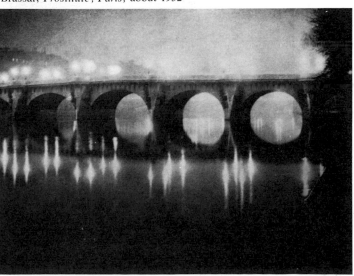

Brassaï, *Pont-Neuf, Paris,* 1949

46
THE PHOTOGRAPHIC ESSAY
A New Way to Communicate

The rise to power of Adolf Hitler and the Nazi Party abruptly ended the great age of German photojournalism. The new German government abolished freedom of the press and forced the best contributors to the magazines into exile.

At the beginning of the 1930s, the finest illustrated weekly in the world was *Vu,* a French magazine published and edited by Lucien Vogel, who followed the German model and employed many German writers and photographers then in exile in Paris.

In those same years, the United States saw the increasing circulation of *Time,* the popular weekly news magazine founded in 1923 by Henry Luce, an American born in 1898 in China. Luce had hit upon a formula with his weekly publications: his idea was to accommodate a world where the need for information had increased enormously, but where the fast pace of everyday life limited reading time. He conceived of a magazine with a clear presentation, brief articles, and an abundance of photographs.

On November 23, 1936, Luce published the first issue of *Life,* designed to report the most important world events; to denounce injustices; and to illustrate, explain, and instruct—all by means of the photographic image. Luce was clearly staking *Life*'s future exclusively on photography. He believed that photographs intelligently structured to tell a story page by page, accompanied by brief texts and captions, were a powerful means of communication. Public re-

Margaret Bourke-White, *Dam, Fort Peck, Montana,* 1936 (*Life* magazine's first cover, November 23, 1936)

sponse was swift. In its first year the magazine sold over a million copies.

The photographer Margaret Bourke-White played a major role in the magazine's initial success. She photographed the first cover story, which reported on the construction of a gigantic dam at Fort Peck, Montana.

Bourke-White was the most prominent of the prestigious *Life* photographers who worked in a new, epic tradition. Among the others the most outstanding were Alfred Eisenstaedt, for his political awareness, and W. Eugene Smith, for his personal concern.

Smith believed that "photography is a potent medium of expression. Properly used it is a great power for betterment and understanding." His goal was to produce not just powerful single images, but photo essays in which a group of photographs told a story. Smith always struggled to keep in balance the roles of "recorder and interpreter of the facts and of the creative artist who often is necessarily at poetic odds with the literal facts." His most acclaimed *Life* assignments between 1942 and 1954 were "Country Doctor," "Spanish Village," and "A Man of Mercy"—a photo essay about Dr. Albert Schweitzer and his clinic in West Africa, Smith's last assignment for *Life*. According to Smith, the sequence and layout chosen by the magazine destroyed his idea of photographing a community as well as a famous man. "The printed result," he said, "was a rough and confusing semi-indication of what the essay should have been." From 1954 until his death in 1978 Smith worked as a free-lance photographer, concentrating on projects that allowed him to fight injustice and maintain his artistic integrity.

By the end of the 1960s, *Life* had reached its peak circulation of seven million copies. Although many of the magazines Luce and his colleagues founded still exist, the advent of television marked the decline of the press as the primary medium for information.

W. Eugene Smith, from *An African Place*, 1954

Henri Cartier-Bresson, *Jerusalem,* 1967

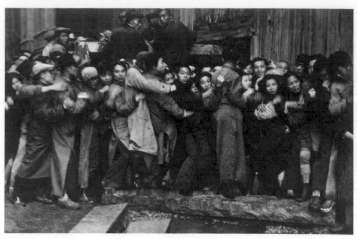

Henri Cartier-Bresson, *Shanghai,* 1949

47

THE DECISIVE MOMENT
Henri Cartier-Bresson

In his book *The Decisive Moment,* Henri Cartier-Bresson wrote: "I, like many another boy, birthed into the world of photography with a Box Brownie, which I used for taking holiday snapshots. . . . Later I met photographers who had some of Atget's prints. These I considered remarkable and, accordingly, I bought myself a tripod, a black cloth, and a polished walnut cam-era 3 x 4 inches. The camera was fitted with a lens cap—instead of a shutter—which one took off and then put on to make the exposure. . . . In 1932, when I was twenty-three, I discovered the Leica. It became the extension of my eye, and I have never been separated from it since I found it. I prowled the streets all day, feeling very strung-up and ready to pounce, determined to trap life—to preserve life in the act of living."

In the years immediately after his discovery of the Leica, Cartier-Bresson took pictures on the streets of cities in Europe and North America, walking in the crowd with his small camera concealed behind his back. His images capture the most significant everyday aspects of individual lives: a man in Paris trying in vain to avoid

Henri Cartier-Bresson, *Srinigar, Kashmir,* 1948

Henri Cartier-Bresson, *New York,* 1963

an enormous puddle by leaping over it; a Londoner asleep in a heap of newspapers beneath a crowd gathered to watch the passing parade of the new king George VI; the tender embrace of two lovers in Mexico City.

Even as he was becoming the best-known photojournalist in the world, Cartier-Bresson was also working in the cinema, directing the photography in several of Jean Renoir's films and making a documentary on the Spanish civil war for Paul Strand's production company. Called up to serve in World War II, he was captured by the Germans but managed to escape and return secretly to occupied France, where he photographed the dramatic days of partisan resistance and the liberation of Paris in 1944.

In 1947 he began traveling again, this time to Asia and Africa. Also in 1947, Cartier-Bresson helped to found Magnum Photos, a cooperative photographic agency that distributes the picture stories of its members to publications throughout the world.

Cartier-Bresson never intended that his photographs, taken at random by his roving lens, should give a complete picture of the countries he visited. From China to India to the United States, he focused his attention on the universal language of human feelings, which, caught in a fraction of a second and recorded forever by photography, can convey the essential meaning of an event.

48

PHOTOGRAPHS OF AN EPOCH
August Sander

In 1910 a young German worker named August Sander began to compile a significant series of photographs. Specializing in portraiture, he created a unique image of his country and the tragedy that convulsed it in the first half of the twentieth century.

Before Sander, photographers occupied themselves primarily with stopping and recording man's actions, not with offering their own interpretations of historic events. Jacques-Henri Lartigue and the other photographers who dedicated themselves to documentary photography produced a record crucial to the understanding of an age—its customs, fashions, and individual and communal behavior. Yet seldom did these early documentary photographs probe the psychological, ideological, personal, and moral background that motivates behavior.

Even the photographs of Felix Man and Erich Salomon, who were active in the same years and same social environment in which Sander worked, and who were especially sensitive to the general political climate of Germany at the end of the 1920s, shed little light on the reasons behind the birth of Nazism and its rise to power.

Sander was born in 1876 in Herdorf, a small town east of Cologne, the third of a miner's nine children. His was a dignified family with solid values. In Sander's world, culture was not just a word found in books; it was a rapport with life, nature, and work.

After finishing elementary school, the young Sander took a job in a local mine. There, at the age of sixteen, through a chance encounter, he was introduced to photography. By 1901 he was director of a studio in Linz, Austria, where he made a name for himself as a fine portraitist. In 1909 he returned to his homeland, settled permanently in Trier, and set up a studio in Lindenthal, near Cologne. Already master of a mature personal style, he began the ambitious project

of making a composite portrait of "Man of the Twentieth Century," part of which was published nineteen years later in the book *Faces of Our Time*.

It was an enormous work: the photographs were divided into seven sections corresponding to class divisions in contemporary society, from the basic level of those who worked the land to the powerful class that held political power. Sander based these divisions partly on physiognomy, the science of determining a person's character from his facial features. In faces

August Sander, *Revolutionaries, Berlin,* 1929

Sander read human nature's eternal suffering and the crisis in values of his own time. He explained the origins of the project in terms of his credo: "People often ask me how I came upon the idea of creating this work: seeing, observing, thinking. . . . Nothing seems to me more appropriate than to project an image of our time with absolute fidelity to nature by means of photography. . . . Photography has provided us with new possibilities and tasks, different from those of paintings. It can reproduce things with grandiose beauty, but also with cruel truthfulness; and it can also deceive incredibly. We must be able to endure seeing the truth, but above all we should pass it on to our fellow men and to posterity, whether it be favorable or unfavorable for us."

When the Nazi Party under Adolf Hitler came to power in 1933, part of their program was to promote the idea of the superiority and purity of the Aryan race, from which all true Germans were supposed to have descended. Sander's portraits violently contradicted their ideas that the purest Germans had the best characters. After repeated searches the Nazis confiscated many of Sander's photographs.

After the arrest of his son, who later died in prison, Sander continued to make photographs but turned to landscapes, hiding his accumulated portraits in a cellar. Unfortunately, his hiding place burned in 1946 after the end of the war, but the surviving work remains an unsurpassed testimonial to Sander's dedication and vision.

August Sander, *Young Soldier, Westerwald,* 1945

August Sander, *Court Usher, Cologne,* 1928

TWO FACES OF ENGLAND
Cecil Beaton and Bill Brandt

While Henri Cartier-Bresson was working in France and Felix Man, Erich Salomon, and August Sander in Germany, Cecil Beaton and Bill Brandt were photographing English life and society. Beaton was born in 1904 to a wealthy family. He took up photography as a young child, collecting the faded picture postcards of the best-known actresses of the day and beginning to photograph at the age of eight or nine with a small Kodak, taking pictures of his sisters Baba

Cecil Beaton, *John Wayne*, 1931

and Nancy and his brother Reggie, artificially posed in costumes, in a soft-focus Pictorial style.

Beaton continued his amateur work during his university years at Cambridge. In 1924 he published a photograph of a student dressed as the Duchess of Malfi in the English edition of the fashion magazine *Vogue*. In the same year, he began working in his father's business, then later in one owned by a friend of the family, but it soon became clear that he was not business-minded.

In 1926, while traveling in Italy, he showed his photographs to Sergei Diaghilev, one of the most important ballet impresarios of the day. Encouraged by Diaghilev's positive response, Beaton decided to open a portrait studio when he returned home. Both the public and the critics soon applauded his portraits of eminent upper-class London personalities. In the 1930s he became one of the most sought-after photographers in England and America, alternating between portraiture and fashion photography, of which he became an undisputed master. Beaton achieved official recognition in 1971, when he was knighted by Queen Elizabeth II, to whom he dedicated some of his best-known images.

In contrast to Beaton, Bill Brandt concentrated on the social contradictions that afflicted his country in the 1930s and 1940s. Born in London in 1904, Brandt spent his youth in Germany and in France. During his years in France he came into contact with the artistic avant-garde movements then converging on Paris from all

Cecil Beaton, *Elizabeth II*, 1955

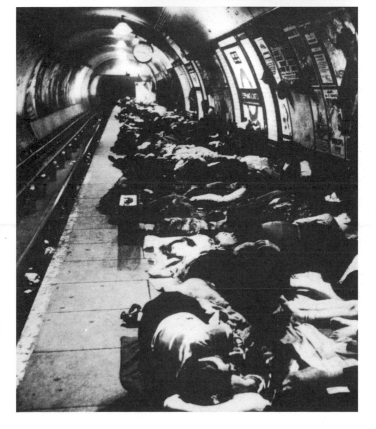

Bill Brandt
Right: *Halifax,
England,* about 1935
Below: *People
Sheltering in the
Tube during the Blitz,
London,* 1941

over the world. These experiences, especially his contact with the American Surrealist photographer Man Ray, helped him to shape his extremely intense and dramatic personal style.

With harsh contrasts created by manipulating the print, Brandt's photographs offered a counterpoint to the gilded world celebrated by Beaton, and they describe with severity *The English at Home* (published in 1936) and *A Night in London* (1938). During the war Brandt photographed the devastation of London by the German blitz, and in subsequent years he extended his work to the female nude, for which he used extreme wide-angle lenses, which distort close-up images.

Beaton's and Brandt's images, though different in style and approach, once again show that the photographer's personality and sensibility are essential and indispensable in the practice of photography.

Robert Capa, *Death of a Loyalist Soldier,* Spain, 1936

50
DEFYING DEATH
Robert Capa

A Hungarian of Jewish parentage, Robert Capa was born André Friedmann in 1913. Forced to leave Budapest in 1931 because of his political activities, he took refuge in Berlin, where he worked as a laboratory assistant for the Delphot Agency, which also employed Felix Man. Eventually, when all of the agency photographers were busy elsewhere, Capa managed to pick up his first photographic assignment.

When Hitler rose to power Capa had to flee Germany in order to escape internment in one of the concentration camps, and he found refuge in Paris, where he soon made a name for himself as one of the most intelligent reporters of political events.

In July 1936 civil war erupted in Spain between the political rightists, led by General Francisco Franco, and the Popular Front, a leftist coalition that had just been voted into power. Young leftists rushed from all over the world to join the International Brigade in defense of the Republic. Among them was the young photographer sent by *Life,* Robert Capa.

Traveling with his German companion, Gerde Taro, and the writer Ernest Hemingway, Capa covered areas where the fighting was heaviest.

Robert Capa, *D-Day, Omaha Beach,
Normandy, France,* June 6, 1944

During a skirmish in the mountains around Madrid he made *Death of a Loyalist Soldier,* a classic photograph that epitomized the tragedy of all wars, as well as the conflict in Spain. The militiaman is caught by the camera the very moment he is shot, his arms flung wide in death's ultimate surrender.

When his longtime friend Gerde died in the Spanish Civil War in an accident, Capa moved to the front of the Sino-Japanese War in 1938, then to the theaters of World War II. He parachuted into Sicily to follow the advancing allied troops into Italy; in Naples he made a powerful image of a funeral for young men who had died in the popular uprising against the Germans.

On June 6, 1944, he was among the first to land in Normandy with the Allies, and in August he entered Paris with General George Patton's armored divisions and photographed crowds cheering in the streets of the liberated city. He then followed the battles beyond the Rhine that led to Germany's surrender.

After establishing the agency Magnum Photos in 1947 with Henri Cartier-Bresson, David "Chim" Seymour, George Rodger, and William Vandivert, Capa became interested in the new state of Israel, where the first Arab-Israeli war had just begun.

Always on the move, Capa spent most of his life on battlegrounds. His defiance of death came to a tragic end during Indochina's struggle against French occupation, when he stepped on a land mine near Thai Binh on May 25, 1954.

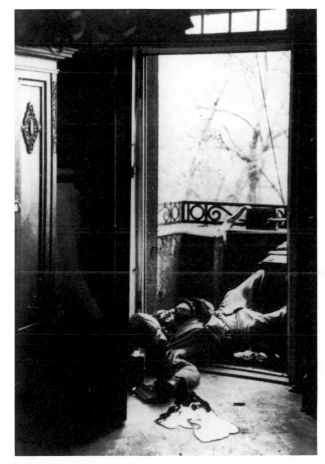

Robert Capa, *Leipzig, Germany,
after the Armistice Agreement,* May 7, 1945

Robert Capa, *German Prisoner of War,
Cherbourg, France,* 1944

Werner Bischof, *Emperor Hirohito Leaving Tokyo, Japan*, 1951

51
FROM GRAPHICS TO GREAT REPORTING
Werner Bischof

Werner Bischof was born in 1916 in Zurich, Switzerland, at that time a flourishing center of the avant-garde, especially the movement called Dada, which celebrated absurdity and nonconformity in the arts. Enrolling in the local School of Arts and Crafts, Bischof took courses in photography taught by Hans Finsler, who emphasized the study of photography in the context of other visual arts. Bischof learned many ap-

proaches to depicting form, that is, how to give structure to creative energy in order to produce a work of art.

In his early years, Bischof supported himself as a graphic artist and used his free time to continue an investigation into the basics of photographic technique, producing evocative effects with reflected light, delicate compositions, and disciplined photomontages. In 1939 he went to

tute, Bischof tried to find the essential harmony and order beneath the dramatic, troubling contradictions of life. The tension between chaos and order emerges in photographs made on similar assignments in countries from Greece to Finland. In 1948, appreciative of the professional independence and social commitment of Capa, Cartier-Bresson, Seymour, and Rodger, he joined Magnum. His contract allowed him to travel all over the world and brought him assignments from the most widely circulated weeklies of the time—*Life* in America, *Epoca* in Italy, and *Paris Match* in France.

In 1951 Bischof traveled to the Indian province of Bihar to document the suffering caused by famine. Here, too, his refined sense of composition restored dignity and beauty even to the most miserable of human beings. While traveling in the Far East, Bischof visited Japan, where he captured the profound spirit of the Japanese people and the measured balance of its ancient civilization, which he found to be thriving in spite of the moral and material destruction caused by the war. Continuing his travels in Asia, he later covered the wars in Korea and Indochina. In 1954 he began a long journey from Mexico into Latin America. In the Andes he made one of his last photographs: a boy playing a flute while walking toward Cuzco along a narrow path suspended between earth and sky. Soon afterward, just nine days before his friend Robert Capa died in Indochina, Bischof was killed when his car plunged to the bottom of a deep ravine.

Paris, intending to devote himself to painting, but the outbreak of war forced him to return home, where he was taken up by the prestigious magazine *du,* and again began to make photographs. Bischof became a regular contributor to *du,* and at the end of the war the magazine assigned him to document the devastated areas in Germany occupied by French troops.

With his images of ruined cities and of men, women, and children left homeless and desti-

Werner Bischof, *Flute Player, Cuzco, Peru,* 1954

David Seymour, *Displaced Child from the Sudetenland, Austria*, 1948

52
THE PHOTOGRAPHERS' COOPERATIVE
Magnum Photos

Elliott Erwitt, *San Miguel, Mexico*, 1962

George Rodger, *Sahara*, 1957

In May 1954, when Werner Bischof died in the Andes and Robert Capa in Indochina, photojournalism was robbed of two of its most important and beloved figures. As daring adventurers, they contributed to the myth of photojournalism as a dangerous and glamorous career; as dedicated professionals, they helped to write in pictures the history of their time.

Both belonged to Magnum Photos, an agency founded in Paris in 1947 to protect the creative freedom and integrity of its members. For political, ideological, or other reasons newspapers and magazines often cut off—"cropped"— significant parts of photographs, or paired a picture with an inaccurate caption, thus changing or distorting the picture's message. The founders of Magnum joined forces to keep control of the pictures they took. The agency was Capa's idea, and his strong personality and enthusiasm attracted David "Chim" Seymour—who, like Capa, had covered the war in Spain—Henri Cartier-Bresson, and George Rodger. Through their courage and self-denial, which often made them witnesses to wars and inhumanity during their assignments, these photographers made a vital contribution to the interpretation of world history as well as to the use of photography as a means of communication.

"Each person had total freedom," Cartier-Bresson recalled. "There was no doctrine, no school. But there was something that bound us strongly together, a certain feeling of respect for reality."

In the cooperative structure of Magnum the admittance of new members had to be unanimously approved. Thus, only the most gifted and sensitive photographers—and those best prepared professionally—were eventually admitted. Over the years Magnum has remained remarkably faithful to its original intentions, providing a base of mutual support, while allowing members the opportunity to pursue their own interests in a wide-ranging variety of projects.

In subsequent years Ernst Haas, Marc Riboud, Elliott Erwitt, Bruce Davidson, Leonard Freed, Inge Morath, Eve Arnold, René Burri, and Bruno Barbey, among others, carried on the great legacy of the founders. But their travels and images, however important, could no longer have the same widespread effect and resonance as those of their predecessors. In accordance with the times Magnum's members have pursued other markets, finding a place for their talent in films, books, and annual reports, as well as newspapers and magazines.

Marc Riboud
Top: *Referendum for Independence, Algeria,* 1962
Bottom: *Zhou Enlai, Peking,* 1971

53
MAKING THE INVISIBLE VISIBLE
Minor White

Minor White was a profoundly spiritual, contemplative artist gifted with extraordinary sensitivity. Through photography he sought to explain—first and most of all to himself—the underlying mystery of life.

Born in Minneapolis in 1908, he earned a degree in literature and biology, then dedicated himself to poetry, believing that "the contemplation of deity in all its manifestations is the true work of the soul." Moving to Portland, Oregon, when he was thirty, he chose to pursue photography, a hobby he had enjoyed since he was a boy. Photography allowed him to reproduce the wondrous beauties of nature and to contemplate the eternal and sacred.

Sent to the Pacific front during World War II, he observed what is generally thought to be the major aerial combat in history, near the Philippine island of Leyte, but he did not photograph the war. His photography during this time was confined to portraits. At the end of the war, White abandoned his literary career, convinced after a few conversations with Alfred Stieglitz, that he could succeed as a photographer.

In 1946 White became associated with Ansel Adams, with whom he taught school in California, and Edward Weston, with whom he often took photographs along the Pacific Coast. At this time White began to group his pictures in sequences interspersed with short poems, later publishing *Mirrors/Messages/Manifestations,* which combined photographs and words.

White believed that "consciousness in photography comes out of an awakening to the interconnectedness of everything." He photographed both natural landscapes and urban views with the same attention to expressive details. With a luminous cloud at twilight or an ominous storm moving across a field, White's photographs inspire reflection on the mysterious presence of the invisible and on the divine power of life.

In 1952 White helped found the periodical *Aperture* with Ansel Adams, Barbara Morgan, Beaumont and Nancy Newhall, and Dorothea Lange "to communicate with creative people and serious photographers everywhere." From the 1960s until the end of his life in 1976, White was a teacher not just of photography but of a meditative, open approach to life. In White's influential workshops, hundreds of students learned to see the world with clearer eyes and to seek their own personal paths in photography.

Minor White
Opposite page, top left: *Smokestacks in the Vicinity of Naples and Dansville, New York,* 1955;
top right: *Pacific Ocean, Devil's Slide,* 1947;
bottom right: *Man and Moon, Matchstick Cove,* 1947;
bottom left: *Black Cliff and Waves, Matchstick Cove,* 1947

54
A PURITY OF VISION
Harry Callahan

Minor White used photography to seek the instant when light would reveal the mystery of life; Harry Callahan contemplated the simple existence of the common man in our century.

Born in 1912 in Detroit, the world capital of the automobile industry, Callahan went to work in the parts department of the Chrysler factory after high school. Like so many others he began to take photographs on weekends as a way of occupying his spare time. His life continued peacefully for years, divided between his job and his hobby. In 1941 the balance shifted toward his hobby. After a lecture for amateur photographers given by Ansel Adams, Callahan began to use an 8 x 10-inch view camera.

The following year, after meeting Alfred Stieglitz, he decided finally to devote himself to photography. A working man turned artist, Callahan seized upon photography's power to represent the ordinary aspects of life that were so familiar to him. His photographs stripped their subjects to the essence of line, form, and light—

Harry Callahan, *Eleanor, Chicago,* 1952

a purity of vision that was Callahan's style. For a few more years Callahan worked in General Motor's photographic laboratories, exploring the technical aspects of photography and enriching his understanding of the artistic side of the medium through meetings with other photographers and with frequent visits to the Chicago Institute of Design, where he experimented with color and with multiple exposures of the same negative.

On the staff of the Institute of Design in 1946, he alternated intense teaching activity with his creative work. His wife Eleanor became his favorite subject. He photographed her taking a Sunday stroll through trees in a park and playing with their daughter at home in their bedroom. In the enigmatic face rising from the waters of a lake, she became a symbol of the feminine; as a body superimposed on the fields and woods of Provence, she became a sign of nature's bounty.

Although he always remained attached to his personal surroundings, Callahan also examined the problems created by society's upheaval in the twentieth century, exposing the alienating aspects of contemporary civilization in scenes of vacationing crowds packed tightly on the beaches of Cape Cod and harried pedestrians lost in their own thoughts as they hurry down busy urban streets.

Harry Callahan, *Eleanor, Chicago,* 1949

A New Awareness

55
THE BEAT GENERATION
Robert Frank

Born in Zurich, Switzerland, in 1924, Robert Frank began to take photographs when he was eighteen. Even in his first images, Frank demonstrated the critical attentiveness to the everyday world that would distinguish his mature work.

At the end of World War II, Frank left Switzerland and moved first to Paris, then in 1947 to the United States, where he lived in an environment that was alien to him—crowds of people moving among densely clustered buildings. Soli-

tary figures and skyscrapers dominate the images he made during this period, where traffic and buildings are reflected, upside-down and quivering, in a puddle. Alexey Brodovitch, art director of the fashion magazine *Harper's Bazaar*, encouraged Frank to seek his own style and subject matter, reminding him that "the photographer's problem is to discover his own language, a visual alphabet that lets him explain the event." In his photojournalism between 1949 and 1952 Frank came to believe that the photographer does not work only with cold machines and chemicals, but also, above all, with the living material of his own inner sensibility.

Frank's sense of bewilderment and isolation in the contemporary man-made world was shared by his poet and writer friends of the Beat Generation. In 1955, while Allen Ginsberg was

composing his poem *Howl,* which lamented the failures of consumer civilization, and while Jack Kerouac was finishing *On the Road,* a novel about young vagabonds wandering the roads of America in search of happiness, Frank received a grant from the Guggenheim Foundation and set out in an old car along the highways of America to make photographs that would say in images what his writer friends were saying in words.

His book, *The Americans,* published in France in 1958, is an acute photographic investigation of life in our time. Frank warned that "the point of view is personal and thus numerous aspects of American life and society are ignored," but he managed to reveal a cross-section of social classes and geographical regions: dominated by cars, juke-box music, restaurants lit up by the electronic images from television sets, and streets of asphalt, cement, and neon. Two years later, Frank applied his vision of contemporary society to film making. As he explained the change in direction, "In making films I continue to look around me . . . looking, explaining . . . hoping . . . telling the truth."

Robert Frank, *Restaurant—U.S. 1 Leaving Columbia, South Carolina,* 1955

Robert Frank, *Public Park, Ann Arbor, Michigan,* 1955

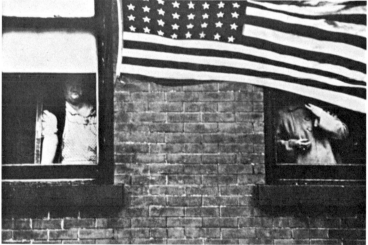

Robert Frank, *Parade, Hoboken, New Jersey,* 1955

Robert Frank, *Las Vegas, Nevada,* 1955

56
BEHIND THE MASK
Diane Arbus

Immediately after World War II the United States experienced unprecedented scientific and economic development. Efficient agriculture; the assembly-line production of automobiles, refrigerators, and televisions; the enormous increase in individual consumption; and the progress in medicine—all contributed to prosperity. But Americans paid for their new wealth with the loss of many of the feelings and values that had once offered hope and strength in the face of life's problems. Diane Arbus's photographs exposed with straightforward clarity the fear, desperation, alienation, and anguish behind this superficial appearance of happiness.

Arbus was born in New York in 1923 and studied at the Ethical Culture School, where Lewis A. Hine was once a teacher and Paul Strand a student. Later, she began a professional career as a fashion photographer. At her death in 1971, she had become a successful artist whose work reached millions of people around the world.

Working closely with the frivolous, ephemeral fashion world, which seemed to suggest that all human problems could be solved with well-

chosen cosmetics and clothing, Arbus learned how beauty, health, and external order—all so sought after today—are often merely false facades hiding inner emptiness.

In her photographs of the fantasy worlds of Hollywood and Disneyland, for example, she showed the unreal, hollow character of the American lifestyle. The marvels of technology may have created the witch's castle from *Snow White,* but the swans in the moat are plastic, and the towers made from papier maché. Arbus's photographs reveal such outward splendor to be as false as old Westerns, where the same showdown between good and bad is enacted woodenly in film after film.

Arbus also turned her camera on New York and its people. In pitiless close-ups, she showed the flaws behind heavy make-up, faces that in the cutting light of the electronic flash, arouse first disgust, then pity. In her controversial photographs of so-called freaks, giants and dwarfs pose naturally in their ordinary, middle-class settings. Arbus's vision upset our ideas of reality, making the traditionally strange look normal, and the everyday look odd. More than a century

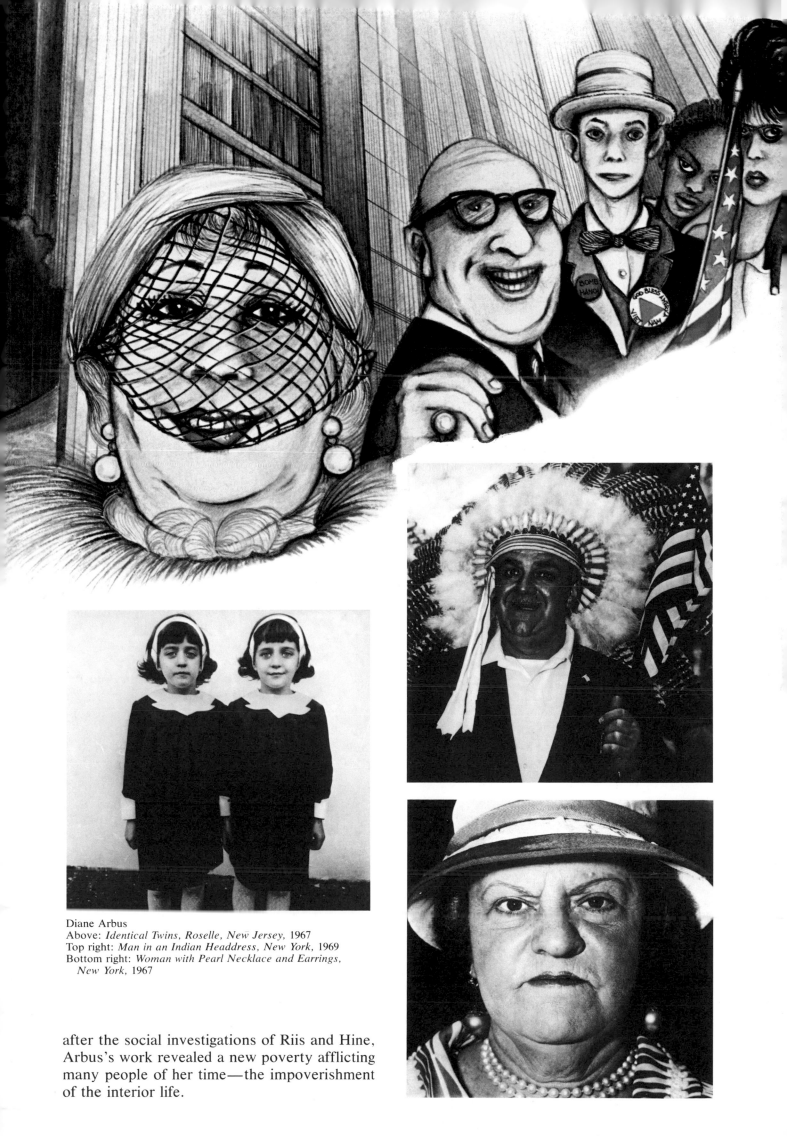

Diane Arbus
Above: *Identical Twins, Roselle, New Jersey*, 1967
Top right: *Man in an Indian Headdress, New York*, 1969
Bottom right: *Woman with Pearl Necklace and Earrings, New York*, 1967

after the social investigations of Riis and Hine, Arbus's work revealed a new poverty afflicting many people of her time—the impoverishment of the interior life.

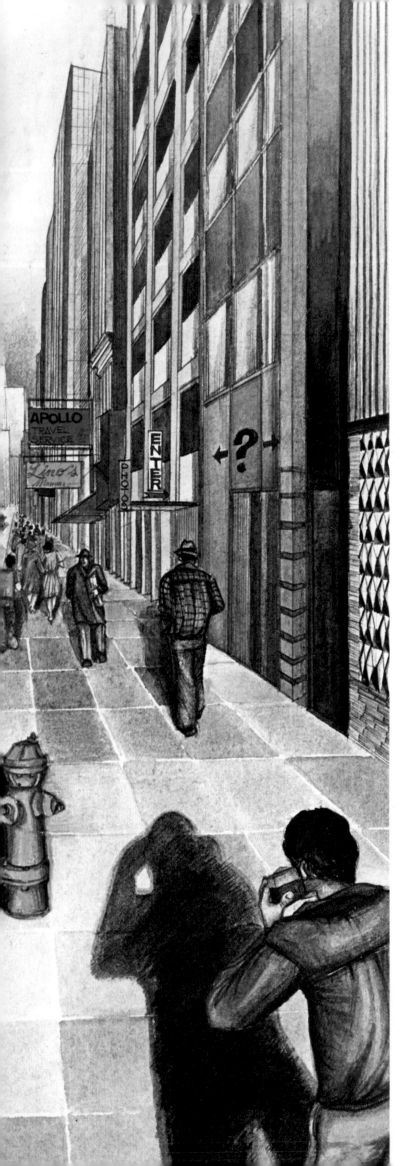

57
THE SOCIAL LANDSCAPE
Lee Friedlander
and Garry Winogrand

In recent decades photography's role as a means of communication has undergone noticeable changes. The advent of television, which has the advantage of bringing into our homes images of an event at the very moment it is happening, has reduced the need for the illustrated weekly magazines and also for photojournalism. Under these conditions photography has had to re-examine its own function and strike out in new directions.

Photographers working in the 1960s and 1970s refused to accept the limitations that assignments in fashion and advertising imposed on their creativity, so they devoted themselves instead to teaching in art schools and universities, realizing their projects independently or with the support of public and private grants. The outlets for showing and disseminating their work were the specialized galleries that have sprung up nearly everywhere in Europe and America, as well as books and limited-edition portfolios.

Lee Friedlander and Garry Winogrand are among this new breed of photographers. Friedlander uses a 35-millimeter Leica to photograph everything from street scenes to flowers to landscapes. His compositions seem random. Some of the subject is obscured while the rest is distorted in the reflection of a car or shop window or in a blur of light. Often his photographs include his own shadow or reflection, the ominous figure of the photographer who follows us on the street, catching us in the restless movement of a faceless crowd.

Like many of his contemporaries, Garry Winogrand does not specialize in a particular subject; he believes that any subject is suitable for photography. The photojournalists put themselves in the background when they covered an event, but for Winogrand it is not the event that is important but the way photography can transform what we see. In the midst of crowds at an airport, on a street corner, in a park, or at a rodeo, he becomes a kind of participant as well as an observer, physically throwing himself into the act of making a picture. To Winogrand the camera is not sacred: it is a tool to be pushed to

Garry Winogrand, *Untitled,* 1968

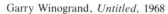

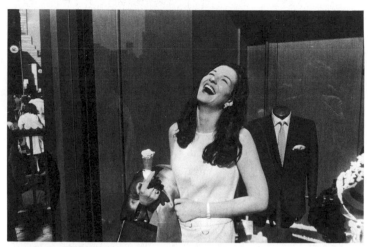

its limits. Instead of concealing his efforts, as Paul Strand did when he started making photographs on the street at the beginning of the century, Winogrand makes picture making part of the activity: sometimes he even takes a photograph without looking through the viewfinder, holding the camera over his head or between his legs. His images, seen in books and on gallery walls, give the sense of the crazy energy and fast pace of modern life, celebrating people and the advanced technological instrument the camera has become.

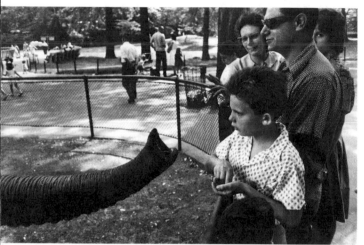

Garry Winogrand, *Bronx Zoo, New York,* 1959

Garry Winogrand, *New York World's Fair,* 1964

58
JAPAN IN TRANSITION

In the West, where photography was born, it grew up first as technology, then found its maturity as an art. This coming of age was a long process, evolving over centuries, of insights, investigations, discoveries, and improvements.

In the second half of our century, however, a non-Western country has played a major role in the evolution and commercial use of photography, becoming in a few decades the foremost world producer of photographic equipment and the home of great photographers.

Until the mid-nineteenth century, Japan had been able to resist the widening sphere of influence of the Western powers. With the arrival of Commodore Matthew C. Perry's ships in 1854, Japan finally had to open its doors, first to the United States, then to other Western nations. From that moment, Japan began to modernize its institutions, while still perserving its cultural identity and age-old traditions. Within a few decades, Japan had acquired modern industrial expertise and had become a great economic power. Its low-priced, well-made, and attractive products, including cameras, flooded world markets. At the same time, several young Japanese began to emerge as important photographers. The first masters of Japanese photography were Ken Domon, born in Yamagata in 1909, and Shoji Ueda, born in Sakaiminato in 1913.

Domon was one of the first photojournalists in the Nihon Kobo Agency. In 1945 he began to explore the complex human, natural, and urban reality of Japan. Using a straightforward, documentary style, he made his spectacular series of images of *Hiroshima, Children of the Chikuho Mine,* and *Pilgrimages to the Ancient Temples.*

Ken Domon, *The Figure of Miroku,* 1954

Ueda, after an initial interest in painting, devoted himself to creative photography and in 1934 founded the Chugoku group, then, in 1948, the Giuryu-sha group. With his spacious, carefully thought-out compositions and his penchant for allusion and the symbolism of the mask, Ueda simply and genially taps the cultural legacy that even today lives on, hidden but unbroken, in the Japanese spirit.

Shomai Tomatsu, Kikuji Kawada, and Ikko Narahara all belong to the generation of photographers who were born in the idealistic 1930s, grew up during the tragedy of World War II, and came to maturity in the tumultuous period of American occupation and postwar reconstruction. In their work the memory of the past is an essential force in the present, one that reflects the intelligence of a nation that knew how to change and adapt to modern pressures without sacrificing its true identity.

Shoji Ueda, *Children's Festival*

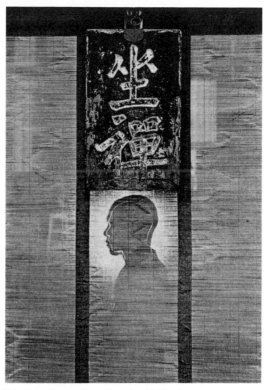

Ikko Narahara, *Zen Temple*, 1969

Kikuji Kawada, *Photograph and Personal Effects of a Kamikaze Commando*, 1965

Joel Meyerowitz, *Ballston Beach, Truro, Cape Cod, Massachusetts*, 1976

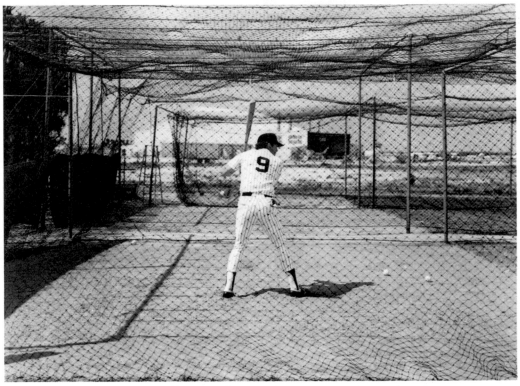

Stephen Shore, *Graig Nettles, Yankees' Spring Training, Fort Lauderdale, Florida,* 1978

59

IN COLOR

The New Generation in America

Joel Meyerowitz was born in New York in 1938. He took courses in painting and medical drawing at the University of Ohio, and, when he finished his studies, worked for a few years in an advertising agency.

Initially, it was curiosity that prompted him to observe the world through the viewfinder of a camera, but he gradually became fascinated by the images emerging from his work. In 1962 he decided to devote himself exclusively to photography and began to travel around America and Europe, taking pictures as he went. Since he wanted his professional work to look more serious than his color snapshots, he began to use black-and-white film. Drawn like so many others to the environments of big cities, he soon showed a unique talent: the ability to seize the unusual moment.

After a period of experimentation that helped him to develop a more mature and personal style, Meyerowitz gave up his small black-and-white pictures in favor of color pictures taken with an 8 x 10-inch view camera. This switch marked the end of his apprenticeship and brought with it changes both in his technique and his way of life. His awareness of time and space, two extremely important elements in photography, were deeply affected. He now concentrates on perfecting a single image, rather than relying on the cumulative effect of pictures

and the candids have been replaced by carefully considered compositions.

Whether the location is Cape Cod on the Atlantic shore or the Empire State Building in New York or the famous golden arch of St. Louis, Meyerowitz documents and follows the changing forms and colors in all seasons.

Nine years younger than Meyerowitz, Stephen Shore has also found his best means of expression in color photography. In the 1960s Shore spent a lot of time at The Factory, the Pop artist Andy Warhol's legendary studio. His only formal schooling in photography was a ten-day course taught by Minor White in 1970. By 1972 Shore had turned exclusively to color, like Meyerowitz specializing in large-scale views made with an old-fashioned professional camera.

Eclectic in spirit, Shore has photographed many subjects, from Claude Monet's gardens in Giverny, France, to the Yankees' spring training in Fort Lauderdale, Florida, to the quiet back roads of America's small towns.

Today, when science and technology put at our disposal ever more refined and sophisticated cameras, the work of Meyerowitz and Shore keenly reminds us that the revelations of photography depend on the eye of a self-questioning individual who unveils the shape of the world and a sense of time and history. Thus, photography transforms mere seeing into beholding.

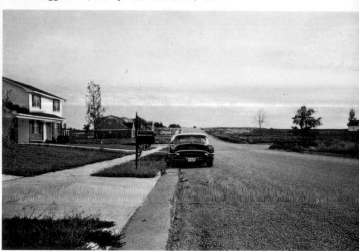

William Eggleston, *Memphis, Tennessee*, 1971

60
SNAPSHOTS TRANSFORMED
William Eggleston

Every day in the world's industrialized countries millions of people photograph the most insignificant moments of their own lives. Photography is now a universal visual language, capable of documenting any aspect of the real world.

Joel Meyerowitz and Stephen Shore use large view cameras, which make the scene appear upside-down on the viewfinder and require exposure times of as much as several seconds. By their deliberation they draw a parallel between themselves and the great masters in the history of art and photography. They draw attention to aspects of reality usually overlooked. William Eggleston has devoted himself to another approach: he probes the meaning of the commonplace—particularly in the American South.

William Eggleston was born in Memphis, Tennessee, in 1939 and has spent his entire life in the South. He uses his everyday experience to describe the lives of people like himself all over the world, in his photographs of car trips, backyard barbecues, and deserted country roads animated only by the presence of a few children or dogs. Eggleston's importance lies in his acceptance of this language as the only one that can communicate the personal experience of everyday life.

The important difference between Eggleston's photographs and the snapshots stored in family albums everywhere is the sensitivity with which Eggleston snaps the shutter; this awareness determines his choice of subject, his uncanny ability to capture the often ignored moments that reveal the underlying value of life.

With the work of Eggleston and those who have followed his example, a prophecy made in 1936 by designer, photographer, and educator László Moholy-Nagy has come true: "The illiterate of the future will be the person ignorant of the use of the camera as well as of the pen."

William Eggleston, *Outskirts of Morton, Mississippi, Halloween*, 1971

William Eggleston, *Southern environs of Memphis, Tennessee*, 1971